IMA
of Am

GLASTON

D1280858

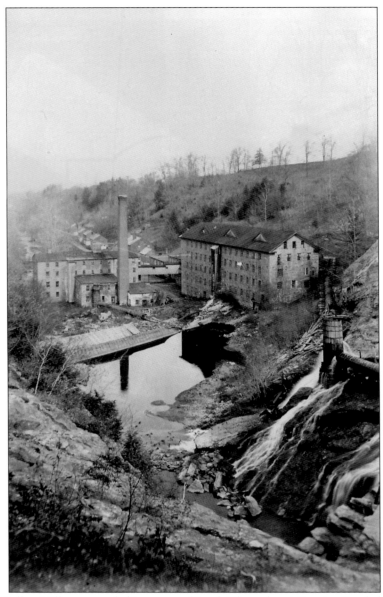

The Cotton Hollow Mills were nestled in a gorge of South Glastonbury's Roaring Brook downstream of a 50-foot-high dam. Today, the facade of the largest structure remains, and the area has been set aside as the Cotton Hollow Preserve. (Courtesy of the Historical Society of Glastonbury collections.)

**ON THE COVER:** In this 1891 photograph, these men are cutting ice with the latest in hand-powered ice cutters. Invented by Glastonbury's Robert Moseley, this machine allowed an easy way to cut ice from the surface of ponds and lakes. In his 1874 patent application, Moseley stated that his invention simplified "the mechanism of an ice-cutting machine so as to be cheap of manufacture, easy and effectual in its operation by one or two men while standing upon the machine." (Courtesy of the Historical Society of Glastonbury collections.)

# IMAGES
## *of America*
# GLASTONBURY

Robert Hubbard and the
Historical Society of Glastonbury

ARCADIA
PUBLISHING

Published by Arcadia Publishing
Charleston, South Carolina

Printed in the United States of America

Library of Congress Control Number: 2011934594

For all general information, please contact Arcadia Publishing:
Telephone 843-853-2070
Fax 843-853-0044
E-mail sales@arcadiapublishing.com
For customer service and orders:
Toll-Free 1-888-313-2665

Visit us on the Internet at www.arcadiapublishing.com

# CONTENTS

# ACKNOWLEDGMENTS

First, I would like to recognize the assistance of Jim Bennett, executive director of the Historical Society of Glastonbury, for answering questions, assisting in the selection of the cover photograph, and doing a final check of the book. The society has the talent and assets of a business and requires someone who can handle all aspects of its operation. That Jim does, and he does it well. I also had the pleasure of working with Phyllis Reed, the society's librarian. Phyllis has exactly what is needed for her position: a great memory for facts, a dedication to her work, and a desire to help other people. Thank you, Phyllis.

I am indebted to Sue Motycka, a woman with an encyclopedic knowledge of Glastonbury history, for the time and effort she took to fact check my manuscript. No one loves Glastonbury more than Sue and no one is more enthusiastic about communicating its history. Countless members of her family have lived in Glastonbury and her dedication to the town's history would make them proud.

I would like to give thanks to Anne O'Connor, one of my most valuable resources, who provided photographs and performed a final check of the manuscript. Also, the following individuals kindly provided information, comments, and materials for the book: Richard Mihm, a man of energy and wisdom; Lin Scarduzio, a gifted enactor who is as good as any I have seen at the Williamsburg or Plymouth Plantation living history museums; and Joe Sullivan, one of the society's greatest assets. Several of the pictures in the book are from Mike Martino's collection of historical photographs. Thank you, Mike.

Thanks also to David Motycka; Fr. John P. Gwozdz, pastor of St. Paul Catholic Church; the Mariners' Museum Library in Newport News, Virginia; the Lutheran Church of St. Mark; and the Welles-Turner Memorial Library.

Unless otherwise noted, all images are from the collections of the Historical Society of Glastonbury.

# INTRODUCTION

Named for Glastonbury, England, Connecticut's Glastonbury was first settled by the English in 1636, while evidence of Native American habitation dates back to ancient times. Situated across the Connecticut River from its mother settlement of Wethersfield, Glastonbury became a shipbuilding center and a manufacturer of gunpowder for George Washington's army. Later, J.B. Williams became the country's first shaving soap manufacturer. He was followed by makers of ship anchors, cotton products, leather products, and aircraft. The largest town by land area in Hartford County, Glastonbury's rich soil led to the establishment of extensive orchards and a world-renown poultry business. Its quarries have furnished the granite used to build Hartford's Wadsworth Atheneum. Today, it is a prosperous residential community, boasting over 150 pre-1800 homes. The only town in the United States with more historic homes is Marblehead, Massachusetts. The town is also known for the Glastonbury-Rocky Hill Ferry on the Connecticut River. Began in 1655, it is the oldest continually operating ferry in the nation.

For almost three centuries, Glastonbury relied on the Connecticut River to ship and receive goods and materials. Around 1825, sailing ships made way for the more reliable steamboats. With the advent of railroads in the late 1800s, many Glastonbury businessmen decided they had no need for train transportation. While many surrounding communities fought to have tracks pass through their lands and stations built in their towns and cities, Glastonbury was committed to building and using ships. The Glastonbury businessmen were proven wrong after 1867 when the state legislature proposed the construction of two railroad bridges south of Glastonbury: one at Middletown and one at Lyme. Their fears were these bridges might obstruct the passage of large ships to and from Glastonbury. The following year, the Middletown Bridge was approved and increasing numbers of manufacturers and farmers chose to use train transport, which led to the demise of Glastonbury's shipbuilding in 1876.

Like many Connecticut towns and cities, Glastonbury was divided up in sections. Two of the oldest divisions in the 1600s were Naubuc and Nayaug. The Native American word *nayaug* means "land of noisy waters," which refers to the abundant waterpower that attracted factories and mills to the town in the 18th and 19th centuries. On Main Street, the dividing line between Naubuc and Nayaug was approximately at Elm Tree Road, with Naubuc located to the north. In later years, major parts of the town included South Glastonbury, East Glastonbury, Buckingham, and Buck's Corner. As their populations grew, they became miniature hubs of commerce, religious activities, and social events.

Waterways, like Roaring Brook, Hubbard Brook, and Salmon Brook, provided ample waterpower for a series of mills manufacturing everything from book cover paper to cotton products. Underwear makers Eagle Manufacturing Company and Glastonbury Knitting Company, Pratt and Post's anchor forge, Hollister and Glazier's woolen mills, and Dean Brothers cotton mill were among the other businesses that flourished, bringing immigrant workers to the town.

During the American Revolution, Glastonbury men served with distinction. At least five African American Glastonbury residents joined the citizens of English heritage in serving in the colonial army, fighting the British in Danbury, Connecticut; Stony Point, New York; and Germantown, Pennsylvania. During the Civil War, the town provided 393 soldiers and sailors. These included Irish immigrants, descendants of Glastonbury's original settlers, and African Americans.

The town's most famous native son was Gideon Welles, secretary of the Navy in Abraham Lincoln's cabinet, and his birthplace home still stands in the center of town. On its porch, Welles and Adm. David Farragut planned the Battle of Mobile Bay, possibly the most important naval battle of the Civil War. Another important historical step was taken when Glastonbury women sponsored and submitted to the US Congress the first antislavery petition. The town's Smith sisters achieved national prominence for their protests against slavery and for women's suffrage. Other celebrated people who have lived in the town include Congressional Medal of Honor recipient John Levitow, hockey legend Gordie Howe, author Candace Bushnell, Samuel Colt, and Noah Webster.

# One

# THE RIVER

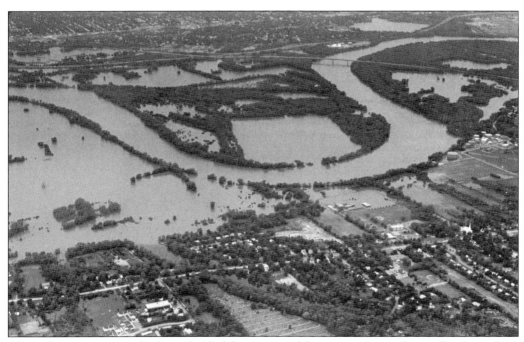

Glastonbury appears in the lower half of this westward-facing aerial view. Major flooding of the Connecticut River has occurred in every century since the founding of river towns in the 17th century. The small white steeple in the lower right of the photograph is the First Church of Christ, while the triangular plot of land in the bottom middle is the Green Cemetery. The horizontal white streak across the lower part of the picture is Main Street.

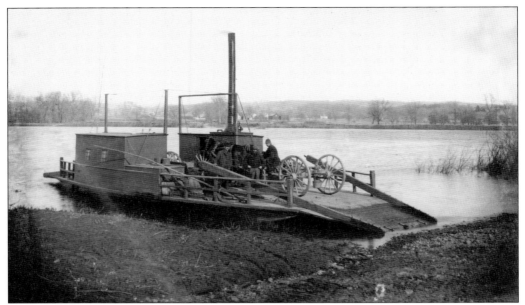

The Glastonbury-Rocky Hill Ferry has crossed the Connecticut River since 1655, making it the oldest continuously operating ferry in the United States. Starting as a raft propelled by poles, it progressed to a horse on a treadmill and then to a steam-powered flat boat, as illustrated here. Finally, today, it is a metal flatboat, the *Hollister III*, pulled by a diesel-powered tugboat, the *Cumberland*.

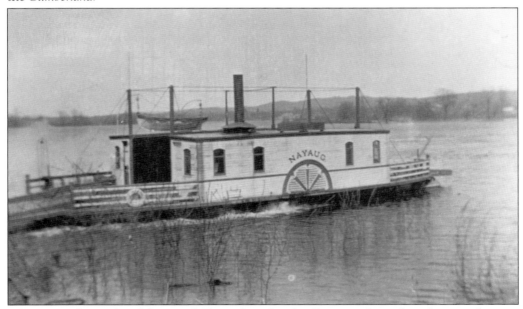

After 1871, when railroads bypassed Glastonbury, local mill owners shipped goods across the river on the ferry where they were placed on train cars at the Rocky Hill Landing. This is a photograph of the *Nayaug*, a steam-powered side-wheeler that ran from 1903 to the early 1920s. When this vessel took its inaugural trip, the ferry service was already two-and-a-half-centuries old. (Courtesy of Mike Martino, Rocky Hill Memories.)

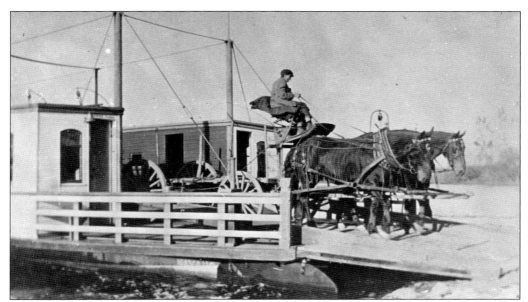

Louis Preli is shown here driving his team off the Glastonbury-Rocky Hill Ferry in 1916. The only alternative crossing points on the Connecticut River were the Bulkeley Bridge of Hartford, completed eight years previously, and the Arrigoni Bridge, which connects Middletown to Portland. The Hartford area's Charter Oak, Founders, and Putnam Bridges were not built until 1942, 1957, and 1959, respectively. A century after this photograph was taken, the ferry still served as an important way to cross the Connecticut River.

Children have always been fascinated by the ferry. For just a few cents, they could check out the fishing on the other side of the River. In 1917, it cost 30¢ for an automobile and driver and 3¢ for each passenger to cross between Glastonbury and Rocky Hill. A one-horse vehicle cost 15¢, while each additional horse was 5¢. Sheep and pigs cost 3¢ each.

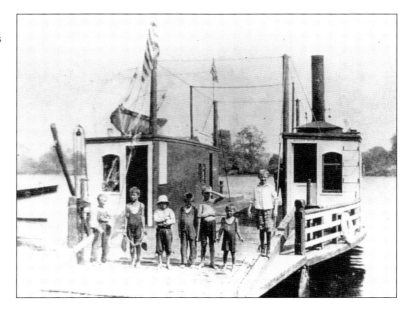

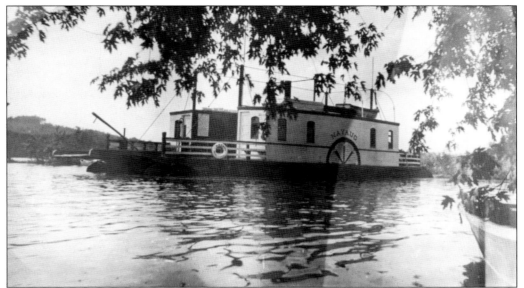

Here is the *Nayaug* as it looked between its first run in 1903 and 1921. The Glastonbury side of the Connecticut River looked much like it does today. Until the late 19th century, the river divided at Glastonbury creating Wright's Island. When the right fork shifted to the left, part of the island disappeared into the river, while the rest became the Glastonbury Meadows.

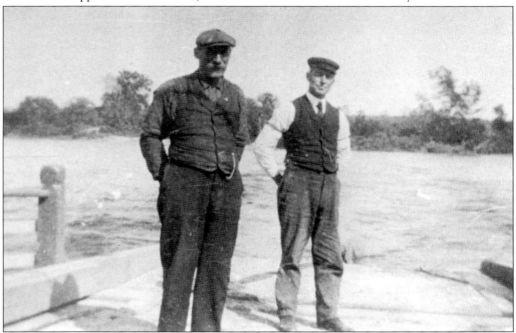

Ferry captain Arthur Taylor (left) and crewman Leonard Hollister stand on the Rocky Hill side of the ferry crossing. In 1915, the ferry was taken over by the State of Connecticut. Today, it is part of Connecticut Route 160 and connects Ferry Lane, Glastonbury, with Meadow Road, Rocky Hill. Motorists can save up to eight miles each way by taking the ferry instead of the Wethersfield to Glastonbury Putnam Bridge.

This 1930s photograph, taken from the Glastonbury ferry landing, looks toward Rocky Hill. Today, the trip by ferry is about 600 yards and takes about four minutes. In 1787, a wedding dress traveled across the river faster than a modern-day ferry; that year, a tornado killed a Rocky Hill woman and blew her dress across the river where it caught on a barn owned by her sister. (Courtesy of Susan G. Motycka.)

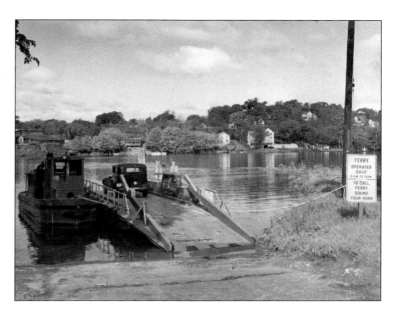

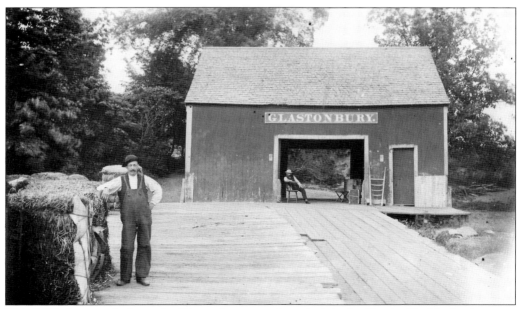

This 1890 photograph shows the Glastonbury steamboat dock in the Curtisville (Naubuc) section of town. Dockmaster William Meyers is seated in the background. In almost every century, the town's name or its spelling changed. When it was part of Wethersfield, the town was called Naubuc Farms. In 1692, the General Court of Connecticut Colony named the town Glassenbury. Around 1786, the spelling Glastenbury became accepted until the present spelling was officially adopted in 1870.

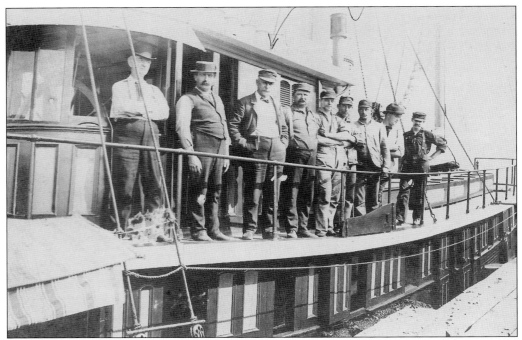

Jared Gaines, pictured in this 1901 photograph, served as captain of the tugboat *Luther C. Ward* for 19 years. In 1904, he assisted in rescuing many people at the *Slocum* passenger steamboat fire. The *Slocum* sunk in New York and took the lives of 1,021 of the 1,342 people on board. In 1916, Gaines died in the same Glastonbury home in which he had been born.

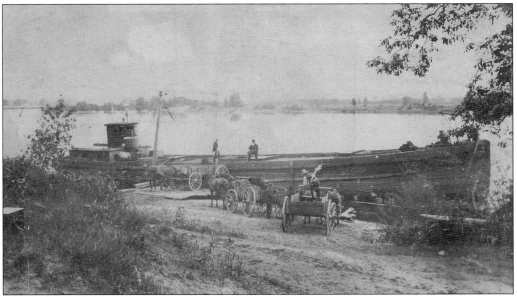

This c. 1900 picture shows coal being unloaded onto horse-pulled wagons. One of the town's two docks was located on Naubuc Avenue, west of today's community center. The other dock was in South Glastonbury, a short distance downriver from the ferry crossing. Since Glastonbury did not have a railroad line, its industrial companies heavily depended on river transportation.

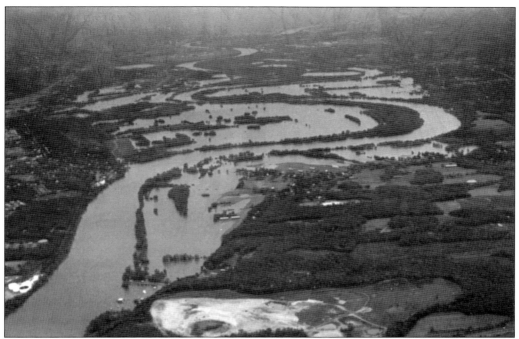

This mid-20th-century photograph shows the Connecticut River looking south from above the Putnam Bridge. The steamboats from Hartford to New York sometimes needed to contend with the flood conditions that blocked access to Glastonbury's two docks. In addition, transportation in the heart of winter was always a tenuous affair as the Connecticut River's ice could make docking impossible.

Capt. Carl Saunders was commander of the tugboat *Sachem* in the early 1900s. He made stops at both Glastonbury docks, connecting communities along the river. Throughout the town's history, shipbuilders, ship owners, and mariners have been leading members of the community.

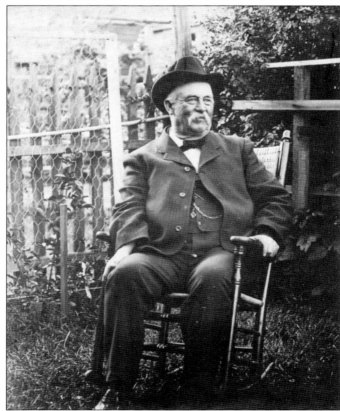

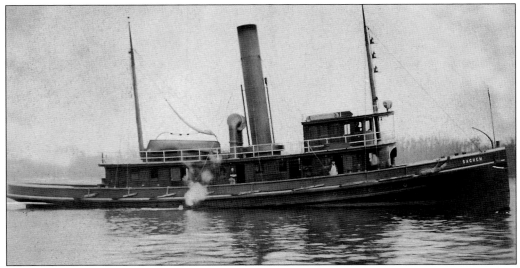

Capt. Carl Saunders's tug is seen here in the early 1900s. Built in Baltimore, Maryland, in 1900, the 111-foot vessel was originally homeported in Hartford, Connecticut. It is believed to have been dismantled in 1955. Today, the only tugboat commonly seen at Glastonbury is the one escorting the Glastonbury-Rocky Hill Ferry across the Connecticut River.

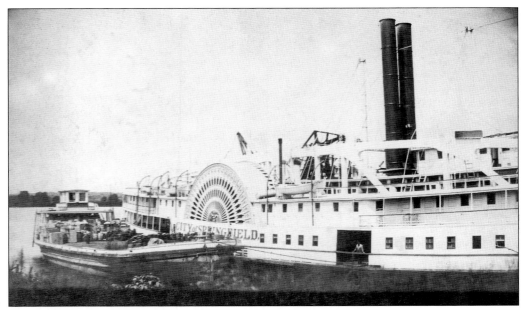

The *City of Springfield* steamboat docked at Glastonbury. In 1899, the Hughes Transportation Company of New York and New Brunswick, New Jersey, bought this vessel from the Hartford & New York Transportation Company. The new owner planned to convert it into a 1,500-ton coal barge.

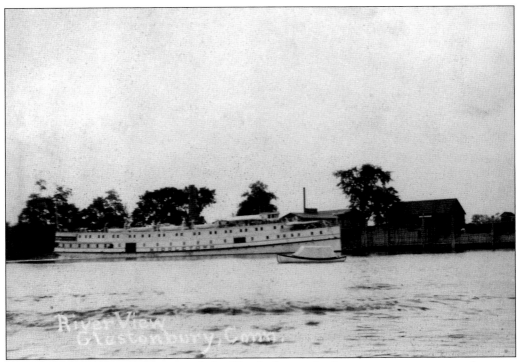

The *Middletown*, pictured here, and the *Hartford* were the last two steam passenger boats to operate on the Connecticut River. Owned by the Hartford & New York Transportation Company, they transported people and freight until the end of the 1931 season. They made daily stops at Glastonbury's two docks.

Pictured are officials at the ceremonies for the new inaugural crossing of the ferry tugboat *Cumberland* and the barge *Hollister III* on December 12, 1955. The Glastonbury-Rocky Hill Ferry is one of only two ferries remaining on the Connecticut River as of 2011. The other ferry, founded 114 years later in 1769, passes between Chester and Hadlyme. (Courtesy of Mike Martino, Rocky Hill Memories.)

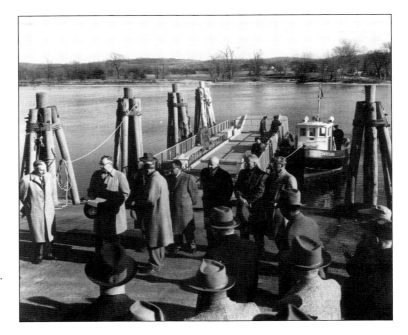

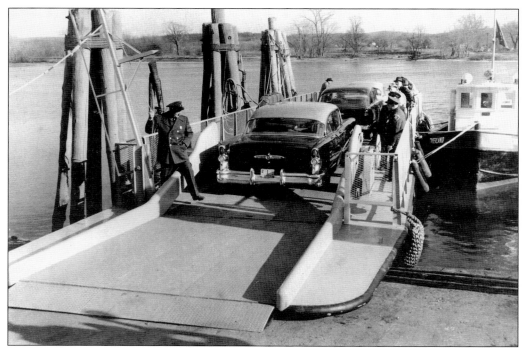

Pictured is the first crossing of the new ferry tug and barge on December 12, 1955. Both were designed by naval architect Walter McInnis (1893–1976). The automobile with its marker plate "1" belonged to state highway commissioner Norman E. Argraves. Among the officials on hand were state representatives Joseph Clinton and Dominic Sylvester. (Courtesy of Mike Martino, Rocky Hill Memories.)

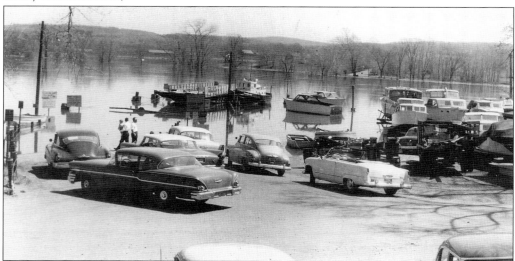

This April 15, 1958, photograph shows the ferry landing flooded, preventing drivers and pedestrians from crossing to Glastonbury. Some curious folks might have come to see how high the water had risen. Others might have been headed across the river to file their tax forms since the April 15 deadline for individuals was established in 1955. (Courtesy of Mike Martino, Rocky Hill Memories.)

# *Two*

# PEOPLE

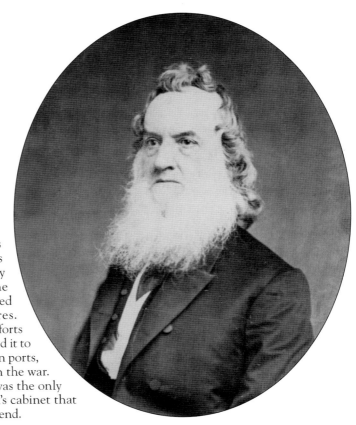

Glastonbury's most famous
native son, Gideon Welles, was
President Lincoln's secretary
of the Navy throughout the
Civil War and later continued
in that position under Pres.
Andrew Johnson. Welles's efforts
to strengthen the Navy enabled it to
successfully blockade southern ports,
greatly helping the North win the war.
It has been said that Welles was the only
member of Abraham Lincoln's cabinet that
the president considered a friend.

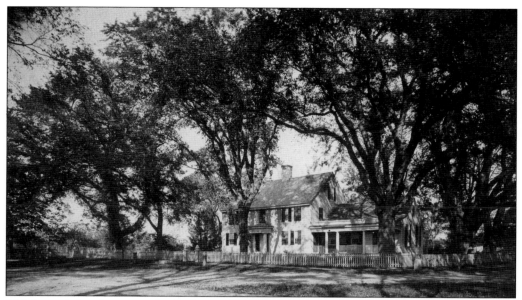

This house is best known as the birth site of US Secretary of the Navy Gideon Welles (1802–1878). At the present time, it is an attractive gift shop. During the Civil War, Welles met with Adm. David Farragut on the porch, which is seen on the right side of this photograph, and planned the Battle of Mobile Bay, one of the decisive naval battles of the war.

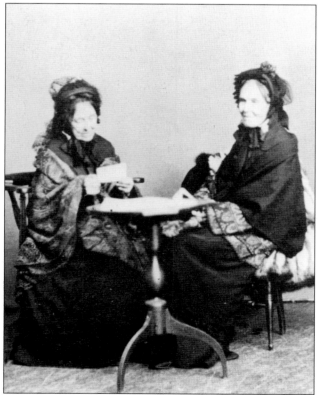

In the late 19th century, Glastonbury's five Smith sisters became nationally known as supporters of the Women's Suffrage Movement. The two most active sisters, Abby Hadassah (1797–1878), on the left, and Julia Evelina (1792–1886) are pictured here. The other sisters were Hancy Zephina (1787–1871), an amateur inventor; Cyrinthia Sacretia (1788–1864), a horticulturist; and Laurilla Aleroyia (1785–1857), an artist.

This is a photograph of Julia Smith, who taught at Emma Willard's boarding school for girls in Troy, New York. In 1872, when Julia and her sister Abby were 80 and 75 years old, respectively, they refused to pay their taxes because they, like all women at the time, were not allowed to vote. They made national news when the town confiscated seven of their eight cows and some of their farmland for nonpayment of taxes.

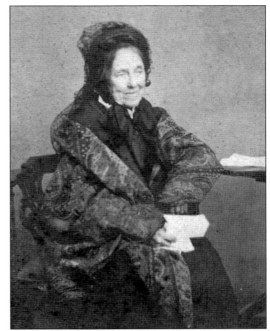

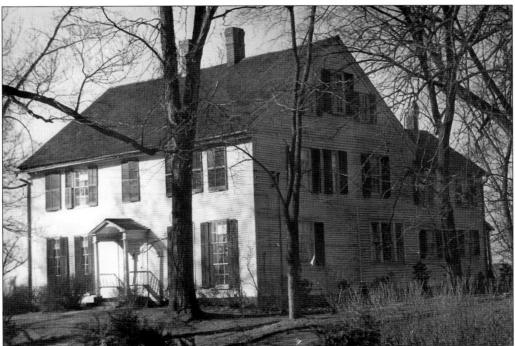

This is a view of the front of Kimberly House on Main Street in 1939. Named after a previous owner, this house was the home of former preacher Zephaniah Hollister Smith (1759–1836), his wife, Hannah Hadassah Hickok Smith (1767–1850), and their five daughters. The Smith sisters lived almost all their lives here. All members of the family actively fought for the abolition of slavery in Connecticut. Slavery was not abolished in the state until 1848.

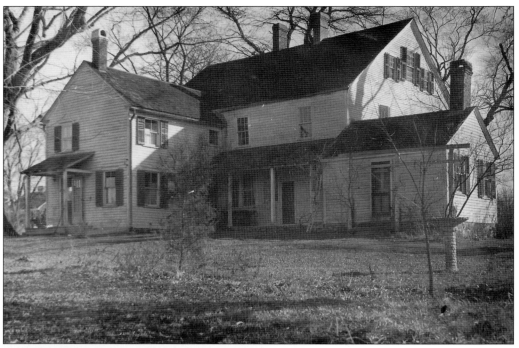

This is a view of the back of the Kimberly House in 1939. In the post–Civil War years, the Smith family took up the cause of discrimination against women. Their tax protests inspired people throughout the country. After all her sisters had passed, Julia Smith became the only one to marry, tying the knot in 1879 at the age of 87. The groom was 86-year-old Judge Amos Parker of New Hampshire. Julia died at the age of 93.

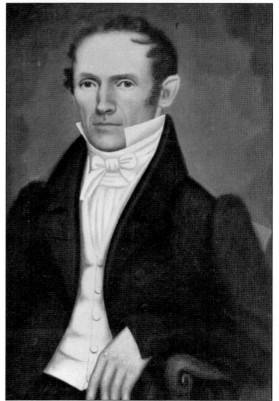

Massachusetts folk artist Erastus Salisbury Field (1805–1900) painted this portrait of Glastonbury's John Hollister. Like most artists of his time, Salisbury would most likely have painted Hollister's face first and then painted in the clothing to fit Hollister's social position. Field lived in Massachusetts for most of his long life, but in the 1840s, he studied with Samuel F.B. Morse in New York City.

Lavinia Talcott was about 17 years of age when this drawing was finished. At about that time, she was engaged to a man who later was lost at sea. This portrait now hangs in the Historical Society of Glastonbury's Museum on the Green on the corner of Main and Hubbard Streets.

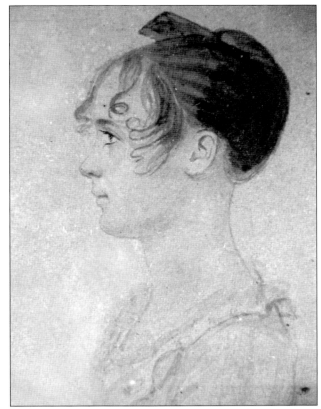

Children at the E.H. Andrews House study under the watchful eye of their mother in this c. 1890 photograph. The house was located just north of the town hall. Glastonbury photographer William H. Wright took this photograph.

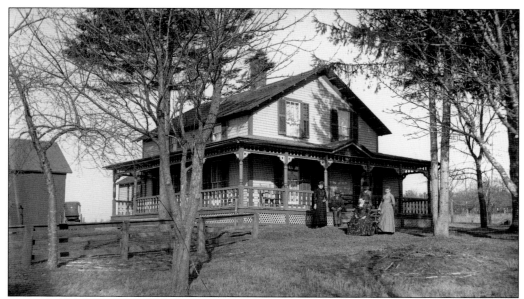

Two c. 1890 William H. Wright photographs appear on this page. The picture below features manufacturer John T. Robertson, his wife, Jessie, sons William and Herbert, and daughter Grace. Born in Glastonbury in 1856, Robertson worked at Glastonbury's J.B. Williams Co. He quit when the company refused to try less abrasive materials in its soap products. Robertson developed a mineral scouring soap and, with investors, started the J.T. Robertson Soap Company in Manchester, Connecticut, a few years before this picture was taken. The soap was named Bon Ami. Starting with bar soap, the company moved to a line of powdered products. By 1903, the company employed 150 workers in its manufacturing operations and continued to grow. Today, the Bon Ami cleansing products are still very popular. Robertson died aboard the ocean liner *Olympia* in 1922. (Both, courtesy of the collection of the Historical Society of Glastonbury.)

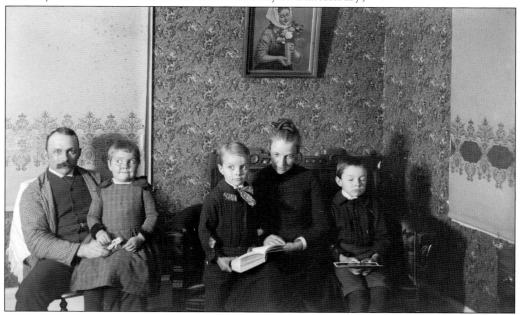

In this picture, photographer William H. Wright (1860–1945) is partially hidden behind his sister Sarah Morgan at the upper left. To the right of them, from left to right, are one of the North twins, Wright's wife, Livi (1866–1906), and Sarah's husband, Oliver. From left to right are (first row) a Kellock daughter, Sarah North Wright, the other North twin, a Kellock son, Henry Wright, and William Wright's sister Mary Kellock.

Dr. William Kingsbury is surrounded by his sisters Lucy, Carrie, Frances, and Mary. The son of Dr. Daniel and Lucy M. Kingsbury, William was born in 1867 and died in 1917. He was a graduate of Trinity College and an 1896 graduate of Yale Medical School. After a year residence in Lowell, Massachusetts, he moved to Glastonbury where he practiced medicine for the rest of his life.

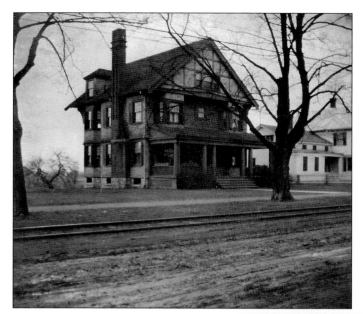

Here is Dr. William Kingsbury's house on Main Street in 1913. This was also the year that the East Haddam Electric Light Company began providing power to Glastonbury for the streetlights on Main Street. Doctor Kingsbury lived here with his wife, Mary Raymond, of Boston. They were married in 1898. Doctor Kingsbury was often seen driving down Main Street in his 1905 Pope Toledo, one of Glastonbury's first "horseless carriages."

Isabelle Hale and her younger brother George Hale Jr. pose for this studio photograph. Along with their older sister Margery, they lived in a house with a peach orchard on the east side of Main Street across from the American Legion Building. Isabelle died relatively young of polio and is buried in the old church cemetery.

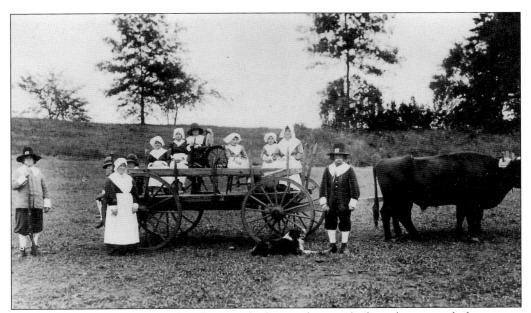

This photograph captures David Hollister and other residents garbed in pilgrim-era clothing using an earlier form of transportation and historic weapons as they enjoy their 1926 town celebration. English settlers first occupied Glastonbury land only 16 years after the real pilgrims landed at Plymouth Rock.

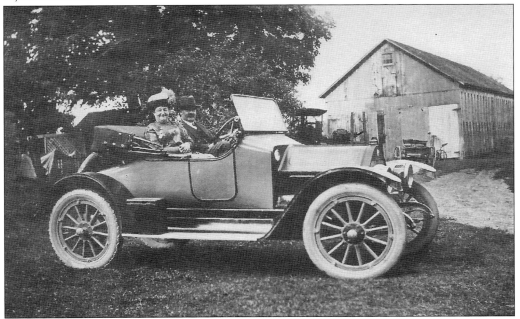

Around 1927, Deborah Goodrich Keene and Elijah Keene pose in their car for a photograph as they leave their backyard of the Goodrich House at 2016 Main Street. Doctor Keene was a noted veterinarian. His office was in the barn off to the right. Deborah was the great-grandmother of Sue Motycka, former president of the Historical Society of Glastonbury. (Courtesy of Susan G. Motycka.)

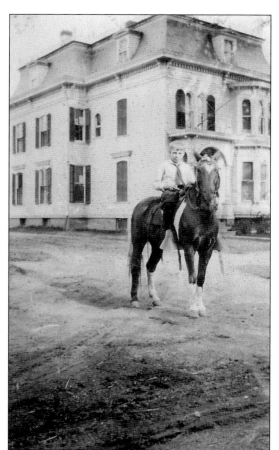

Frances Hale built the Goodrich House at 2016 Main Street for her daughter Deborah and son-in-law John Q. Goodrich in 1874. Her great-grandson John Quincy Goodrich (1906–1993) poses in front of it with his horse. He was president of State Savings Bank, located at 39 Pearl Street, Hartford, and was responsible for opening its Glastonbury branch. State Savings was a predecessor of today's People's Bank. (Courtesy of Susan G. Motycka.)

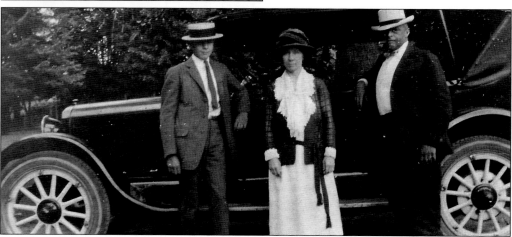

From left to right in this mid-1920s photograph are John Q. Goodrich, his mother, Helen "Nellie" Griswold Goodrich, and his father, Charles E. Goodrich. At the time this picture was taken, John was a student at the University of Pennsylvania's Wharton School. Helen was the daughter of James O. Griswold. Charles was a state legislator, a tobacco farmer, and, for many years, was a county commissioner. (Courtesy of Susan G. Motycka.)

Dr. Lee J. Whittles began his medical practice in Glastonbury in 1923. The list of titles for his community involvement is long and includes the following: the founder of Boy Scout Camp Goodwill, an advocate of the municipal sewer system, a chairman of the town planning commission, the vice president of the chamber of commerce, and the medical examiner of Glastonbury and Marlborough (1923–1945). Doctor Whittles was the founder and first president of the Historical Society of Glastonbury.

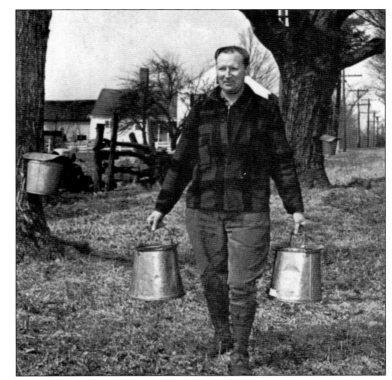

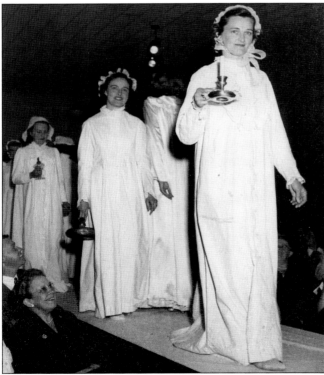

Jean Rebman, Annette Hamlin, and other young ladies of Glastonbury parade in their 19th-century nightgowns in this "A Century of Fashion" show presented by the Historical Society of Glastonbury on April 27–28, 1951. Almeda Kellogg, Wendell Hawkins, William Howard, and Robert Rider provided music for the show.

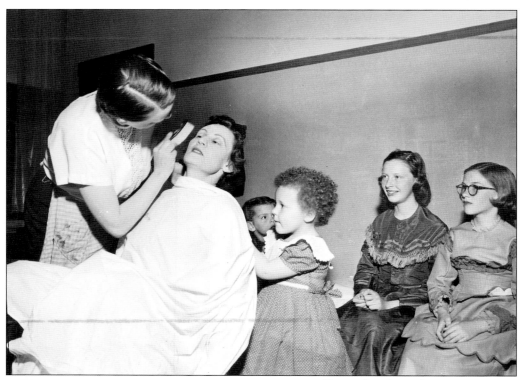

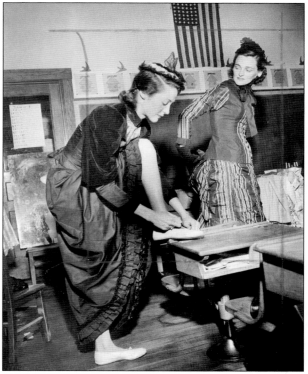

Pictured is the makeup room at the historical society's 1951 fashion show with Mary Doherty, Robin Miller, Susan Goodrich, and Ann Putnam. Perhaps the largest show of its kind in town, 10 people were in charge of costumes, seven were responsible for sets and props, and eight were assigned to programs and publicity.

Janet Cotton and Jean Rebman make last minute adjustments before the historical society's 1951 fashion show. Proceeds from the show were used by the historical society to equip the historical materials rooms in the Welles-Turner Memorial Library. The dedication ceremony for the new Welles-Turner Memorial Library took place the following year.

# *Three*

# HOUSES AND STREETS

This John Hollister House photograph is from the 1890s. The house, which is located at the corner of Tryon Street and Pease Lane, is the oldest house in Glastonbury and one of the five oldest in the state. The original section was built in 1649 on the bank of the Connecticut River where it was subjected to flooding. It was moved near the Roaring Brook Bridge in 1721.

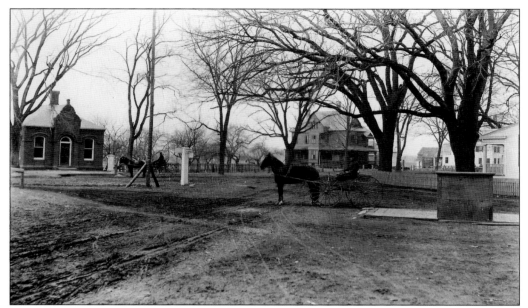

Upon dirt roadways, two horse-drawn carriages traverse Glastonbury Center in 1886. On the left is the Hall of Records, built five years earlier. In the center of the picture stands the large Welles-Turner-Burnham House. In 1952, this house was moved to 2247 Main Street, and the public library was built on its site. The house on the far right is the birthplace home of Gideon Welles, Abraham Lincoln's secretary of the Navy.

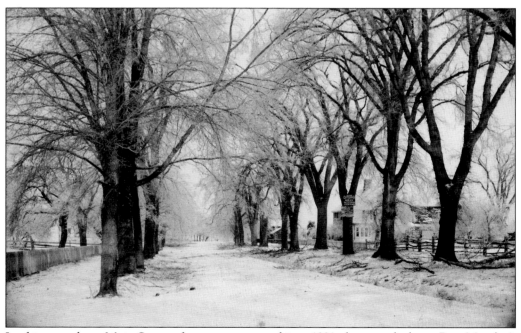

Looking north on Main Street after a snowstorm, this c. 1891 photograph shows Bert Moseley's home on the right. The two signs nailed high up on a tree advertise the Henry Geeley and A.L. Foster & Co. clothing stores on Asylum Street in Hartford.

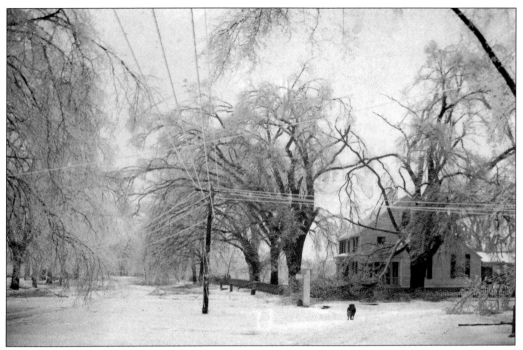

This photograph was taken on January 18, 1891, at Welles Corner, the corner of Main Street and Hebron Avenue, after an ice storm. The Gideon Welles birthplace house on the right was later moved twice. In 1936, it was relocated to a rear lot farther east on Hebron Avenue when a new post office was built on this corner. In 1972, it was moved to a spot near its original site.

This is Welles Corner in the 1890s when Main Street, Hebron Avenue, and the New London Turnpike converged at a rotary. In the 1970s, redevelopment rerouted the turnpike, leaving only Main Street and Hebron Avenue to intersect at this spot. This place is still a major center of commerce for the town.

In this picture, members of the Williams family are visiting photographer William Wright around 1890 at the Joseph Wright House. Wright, who was a master of glass-plate photography, took this photograph. Created using a light-sensitive gelatin emulsion, his plates have survived more than 120 years of storage. Wright died in Fargo, North Dakota, in 1945, but there is a marker for him in the family plot in Glastonbury's Green Cemetery.

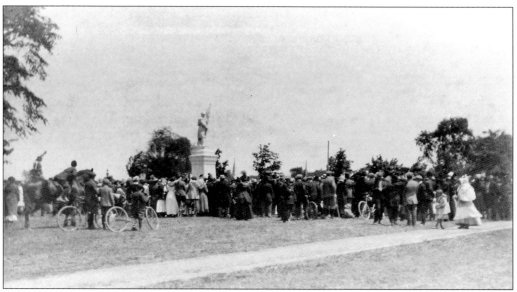

Residents are shown gathering on the Old Town Green in 1913 under the gaze of the recently unveiled Civil War monument. Mercy Turner Barber had the monument erected to honor the memory of her husband, Capt. Frederick M. Barber, and the other soldiers of Glastonbury who died in the Civil War. Captain Barber died of wounds incurred at the Battle of Antietam.

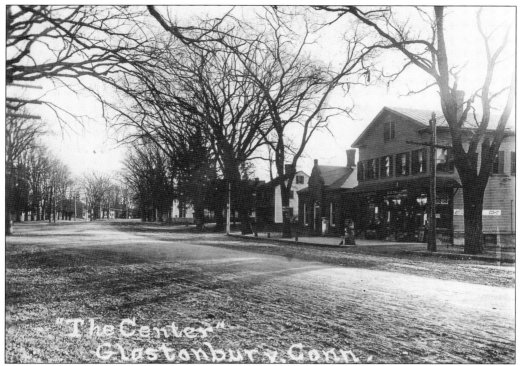

This c. 1910 view looks south down Main Street from the corner of Main Street and Hebron Avenue. The Olcott Building appears on the far right. Next to it is the brick town records building. In 1917, the Olcott Building was destroyed by fire. At the time, it housed Cassius Risley's grocery store, Henry Torbert's plumbing shop, and C.O. Talcott's drugstore. After the fire, it was replaced by Franklin's Pharmacy.

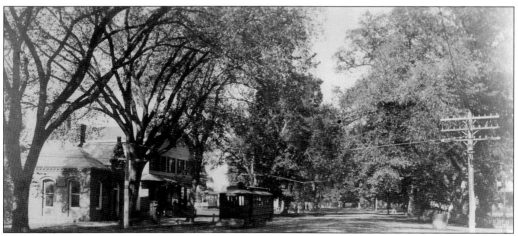

This photograph, taken around 1917, is looking north at Glastonbury Center. The town records building is at the far left. Next is Talcott's drugstore. This area was known as station No. 35 because of its trolley stop number. Many of the Italian immigrants who helped to lay the tracks were later responsible for the success of Glastonbury's orchards. Bartholomew Carini, owning 1,500 acres in Glastonbury, became the largest landowner.

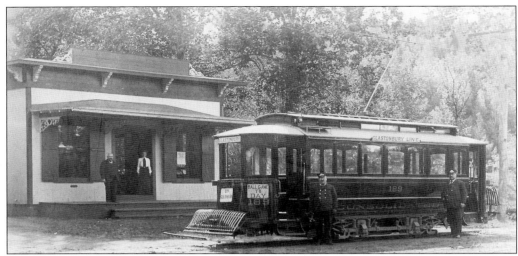

The No. 189 trolley with motorman George Fay and conductor Jim Robinson stands ready to take passengers to the ball game. Postmaster Adelbert Crane and his assistant Mary Shipman are watching from the porch of the South Glastonbury Post Office. The electric trolley line was extended from Hubbard Brook to Roaring Brook in South Glastonbury in 1893.

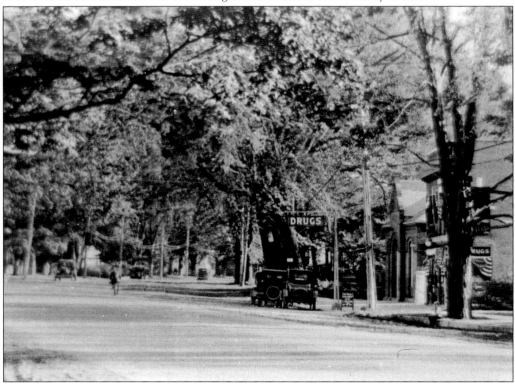

This is Glastonbury Center as it appeared in 1919. The sign in front of the drugstore advertises ice cream. Two years later, Marcus and Lee Franklin bought the business and renamed it Franklin's Pharmacy. After they retired in 1944, Lee lived in Treasure Island, Florida; Stamford, Connecticut; and at the end of her life moved back to Glastonbury. She died in 1995 at age 95.

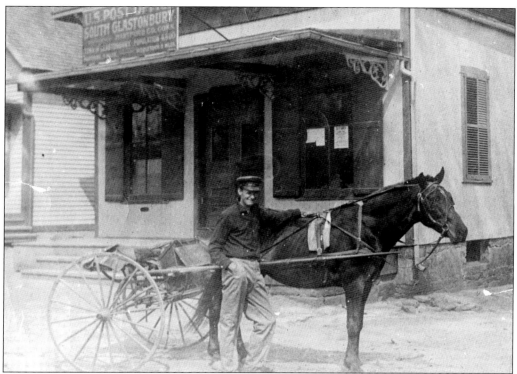

Harry Ferry delivered the mail to Glastonbury residents from 1905 to 1942. For the first nine years, he used the horse cart in this picture. Harry and his wife, the former Lillian Pelton, raised their 16 children on their 12-acre farm. Their 13 girls and three boys were born over a spread of 25 years. When Harry retired at age 59, his wife showed off her rattlesnake belt and pocketbook for a reporter. They were made from rattlesnakes her husband killed early in his career near the Marlborough line. The South Glastonbury Post Office, as pictured below, was a familiar sight for Harry. The sign above the entrance announces, "Town of Glastonbury population 4,800, Hartford 9 miles—Middletown 9 miles." The building to the left is the salesroom of Hopewell Mills. (Both, courtesy of the collections of the Historical Society of Glastonbury.)

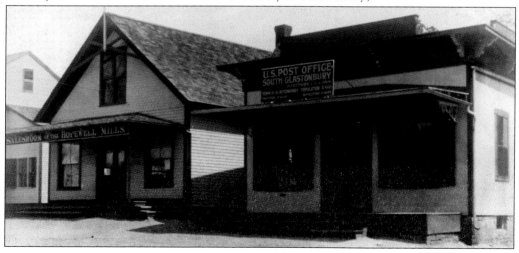

This image is looking north on Main Street after a snowstorm. The origins of Main Street date back to a 1670 General Assembly order to lay out a highway that was "Sixe Rod Wide upon the up-land on the east side of the Great River." The original land was purchased from Native Americans who lived in this area. The narrow plots of land extended from the river to its interior.

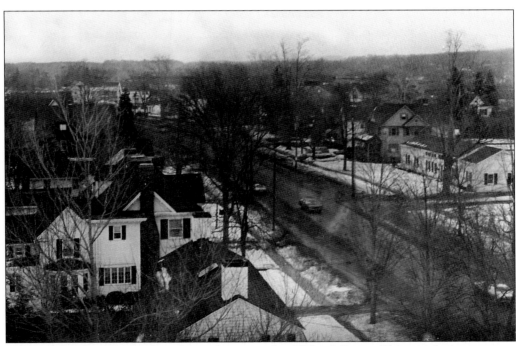

This image is looking north on Main Street south of School Street. This aerial view captures the telephone building on the right. Main Street has always been the heart of the town. Since Glastonbury did not have a railroad line, many goods from factories and businesses were transported down Main Street by truck or trolley. Today, the great majority of Glastonbury's most historic homes line Main Street.

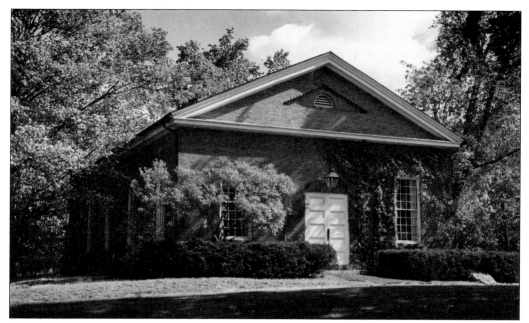

Built in 1840 on the site of the original town meetinghouse, the old town hall sits next to the Green Cemetery. It is now the home of the Historical Society of Glastonbury and its Museum on the Green. In addition to its research library, the professional, quality museum contains a display of Native American artifacts, a Glastonbury schools exhibit, J.B. Williams Co. soap factory products, a Civil War display, and much, much more.

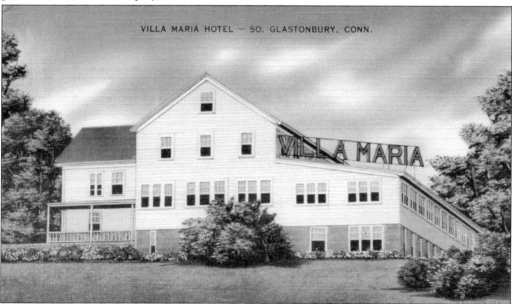

In 1935, Giuseppe Miglietta bought a farm house from the Hollister family and turned it into a popular summer resort named after his wife, Maria. He added a pool, bocce court, and world-class restaurant. Giuseppe was a former chef with New York City's Waldorf-Astoria. (Courtesy of Anne P. O'Connor.)

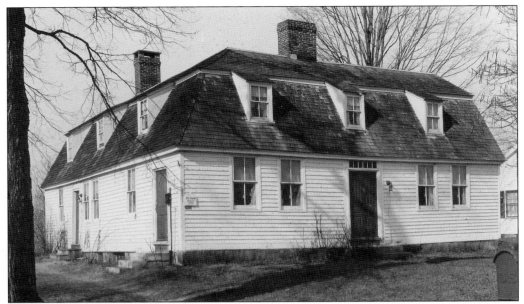

The Wickham House at 2017 Main Street is one of Glastonbury's five surviving 17th-century houses. It was built on the site of a three-mile-long farm that Thomas Wickham of Wethersfield gave to his son William in 1685. When constructed, it faced south. In about 1717, a section was added to the house facing east with a new entrance, fronting on Main Street, which had been laid out in 1698. Today, it is known as "the house that turns a corner."

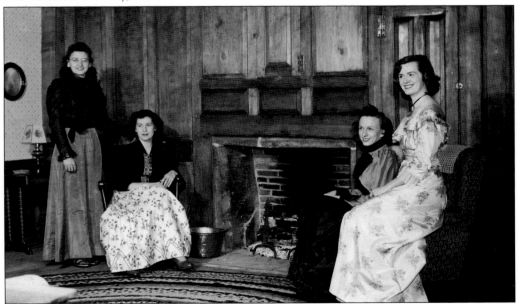

Pictured is an open house at the William Wickham House in May 1948. In 1716, William Wickham gave the house to his son John as a wedding present. Today, it may be the only L-shaped, half-gambrel house in existence. The house has batten doors and paneled fireplace walls. Both sections of the house have their own central chimneys. Their fieldstone bases are between eight to 12 feet square.

For Glastonbury to be recognized as a town separate from Wethersfield, it needed a minister. It is believed that this house was built in 1693 to attract Timothy Stevens (1666–1725). Reverend Stevens was given a choice between a 20-foot-long house and a 40-foot-long one. If he selected the longer one, he would need to provide the nails, glass, and ironwork. He chose the latter.

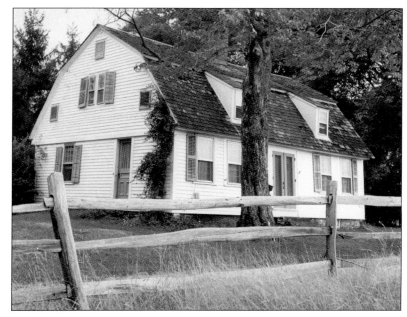

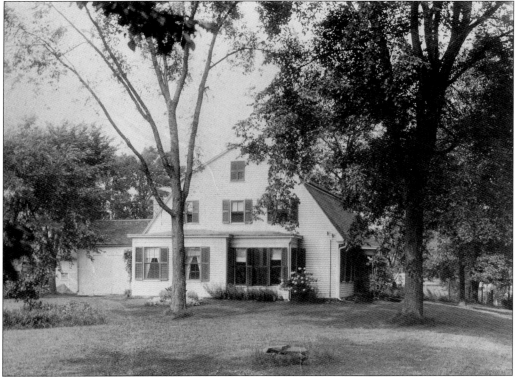

The gambrel-roofed William Miller House at 1855 Main Street is pictured here around 1900. This was about the time the first water main was laid on Main Street. William Miller's father purchased the land in 1660, and William built this house in 1704. William died one year after he moved in. Today, like most of the town's historic residences, it is being lovingly maintained by its owners.

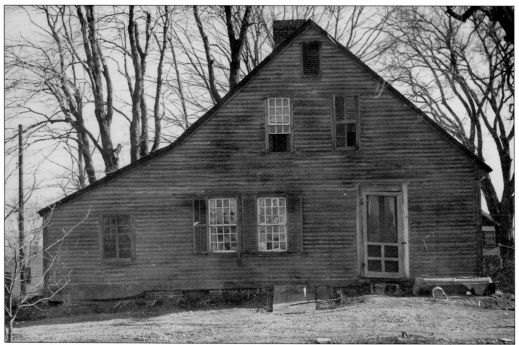

Constructed in 1720, the Hubbard House was located next to land given by John Hubbard Sr. for Glastonbury's first meetinghouse. This land gift was an important step toward the colony's legislature granting town status for Glastonbury in 1693. The gable front orientation of this house was unusual in American Colonial architecture. This photograph was taken in 1939. Today, it is the oldest house adjacent to Hubbard Green.

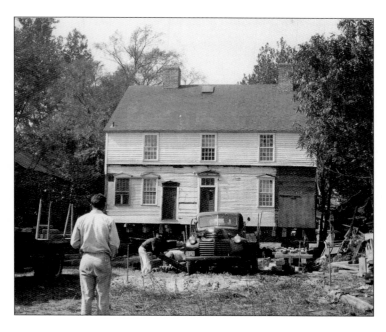

This Georgian-style house was built in 1750 for Elizur Hale who sold it to Ebenezer Plummer, a wealthy merchant and native of Newburyport, Massachusetts. During the American Revolution, Plummer, an ardent supporter of the colonist cause, manufactured potash for gunpowder and also served as a member of Connecticut's Committee of Correspondence, an unofficial government body organized by American patriots.

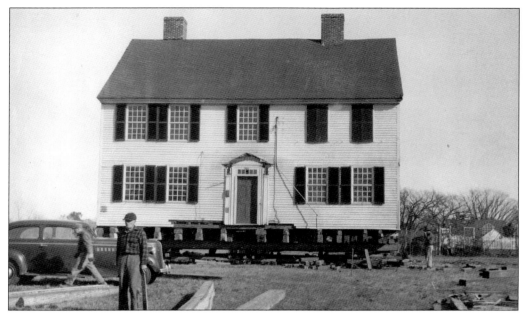

In 1947, when Douglas Road was developed, the Ebenezer Plummer House was moved from the spot where Main Street intersects Douglas Street to its current location at 2094 Main Street. It has been a Glastonbury tradition that when a historic home is slated to be supplanted by another building or use, it is moved rather than demolished. This is an important reason for the large number of Colonial structures in the town.

This photograph of the Bates House at 58 High Street was taken in about 1920. The two-story Colonial has served as a tavern, hotel, and home. When David Hollister built this house in the mid-1700s, he used one of the front rooms as a public tavern. The Bates family purchased it around 1828, retained the tavern, and later turned it into the Bates Hotel.

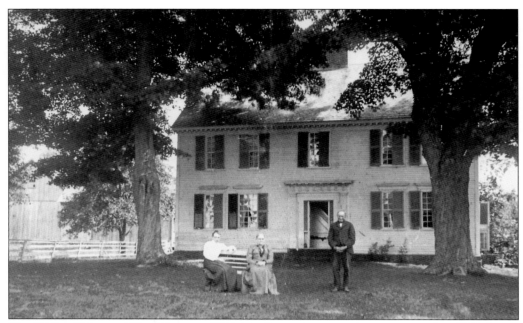

The Welles-Shipman-Ward House at 972 Main Street is captured as it appeared in 1902. It was constructed in 1755 by Glastonbury shipbuilder Col. Thomas Welles and his wife, Martha Pitkin Welles, for their son John. Because of losses suffered during the Revolutionary War, the Welles family lost the house to two creditors in 1789. One creditor, Stephen Shipman, bought out the other man, and his family owned the house for over a century. Dr. and Mrs. James Ward bought the house in 1925, and it stayed in their family until given to the Historical Society of Glastonbury in 1963. The Welles-Shipman-Ward House is frequently used as the venue for historical society events. Recent activities include farm day, days for children, spinning and weaving demonstrations, cooking classes, and an archaeological dig led by the Connecticut State Archaeologist. (Both, courtesy of the collection of the Historical Society of Glastonbury.)

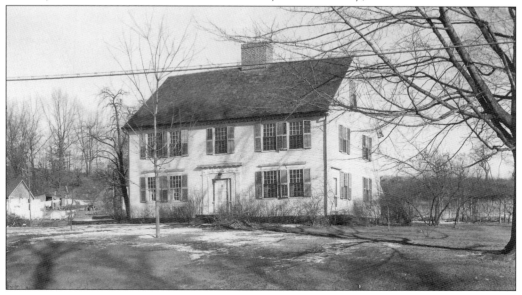

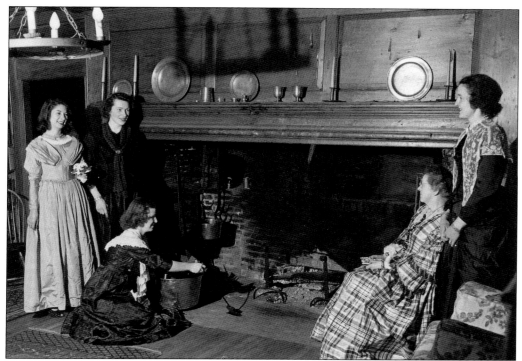

This open house at the Welles-Shipman-Ward House in May 1948 offers a glimpse of the past. These women were hostesses in the Historical Society of Glastonbury's Open House Program. This Colonial home's fireplace is one of the largest found in Connecticut. The house has been restored with period furniture, a spinning wheel, a loom, and a variety of historical furnishings. The house has a small garden and a large, fully restored 19th-century barn.

This is a photograph of the Isaac Moseley House at 1780 Main Street taken in 1939. Built in 1761, the house served as the homestead of the Moseley family. The farm stayed in the family for 257 years—one of the longest cases of a single family owning the same farm in US history. The last Moseley owner, Albert, operated a dairy for 47 years.

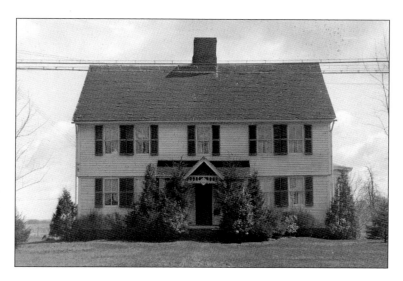

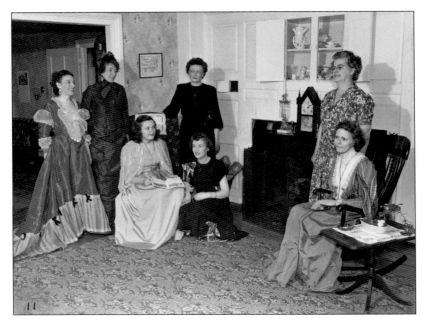

Pictured is open house at the Moseley Tavern at 1803 Main Street in May 1948. The hostesses are, from left to right, Mrs. F. Howard "Dot" Carrier, Ethelwyn "Thel" Carrier Bartlett, Jane Carrier Nystrom, Sarah Ottaley Carrier, Winnie Friel, Rena Packard, and unidentified.

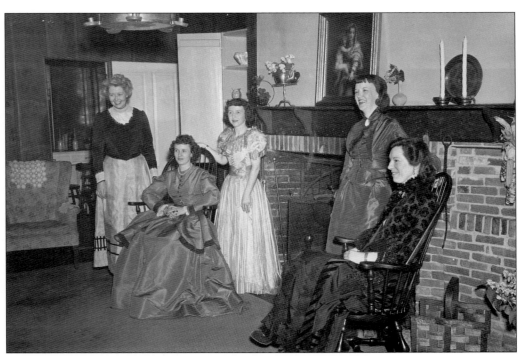

Pictured is open house at the Jonathan Hale House in May 1948. These women, hostesses in the Historical Society of Glastonbury's Open House Program, are adorned in period dress amid the home's antique furnishings. The historical society periodically gives tours of the town's oldest homes. The 2009 tour attracted more than 400 paying guests.

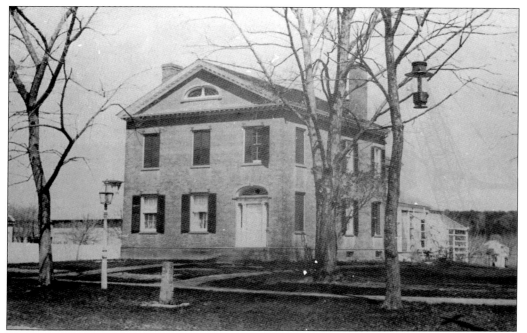

This Federal Period brick house at 2200 Main Street was built around 1828. It has been said that Henry Benton built this home to entice a New York City woman to be his bride, but when he lost the house due to financial problems, it became known as "Benton's Folly." After 1847, it was the parsonage, or home, to the First Church of Christ's ministers for a century. It is now privately owned.

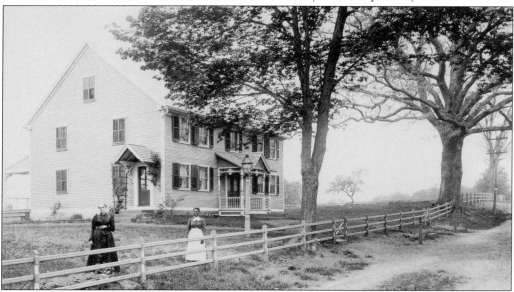

The Gideon Hale House at 1401 Main Street was built about 1762. Tradition has it that after their wedding on December 23, 1762, Gideon Hale, his bride, Mary White, and their wedding party rode on horseback across the Connecticut River to this new house. A severe snowstorm prevented everyone from leaving for a week until the roads cleared up. The couple had 11 children. Gideon died at age 75; Mary died at age 80.

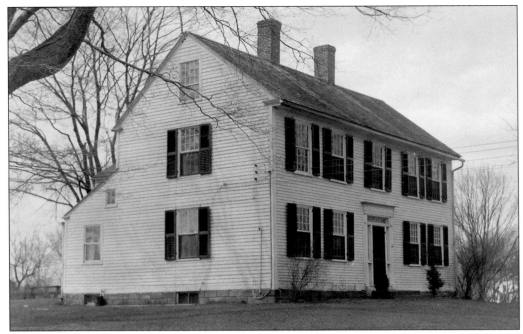

The William Welles House at 1559 Main Street is pictured here in 1939. Built in 1750, it is believed to be one of the houses in Glastonbury that was used as a residence and classroom for Yale College students during the American Revolution. British ships were threatening New Haven Harbor, and the college sought to remove students from harm's way.

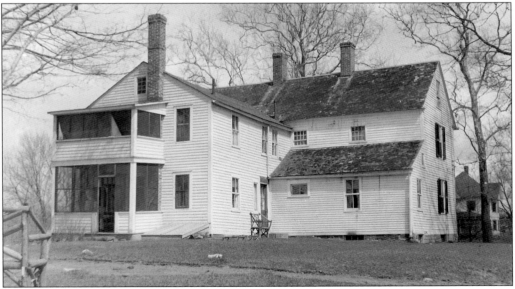

Here is the backyard of the William Welles House in 1939. Although parts of the house have been modified over the years, the main section of the house where it is believed that Yale students were housed still remains. One of the Yale students staying here in 1777 was 17-year-old Noah Webster. According to his diary, he taught in Glastonbury after he graduated. Noah is well known for writing the first American dictionary.

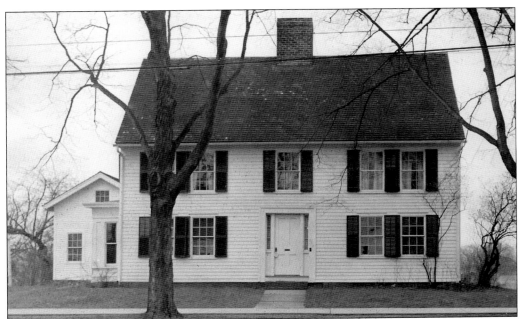

Seen here is the east view of the Benton House at 2213 Main Street in 1939. Most likely, this house was built by Josiah Benton (1705–1783) in the 1730s for his wife, Hannah House Benton, and their four children: Prudence (born 1736), Mary (born 1739), Edward (born 1742), and Josiah (born 1745).

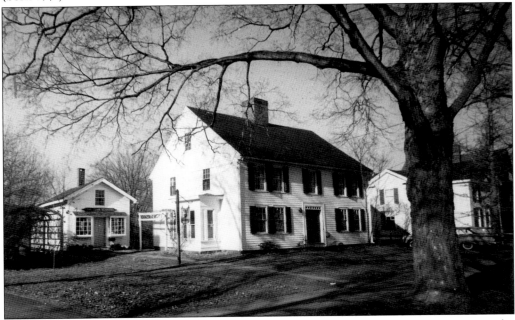

Here is a more recent photograph of the Benton House. When Josiah Benton died in 1783, he left his property to his two sons. It is believed that son Josiah Jr., with a wife and five children of his own, moved back into this house at that time. The small building to the left was once a law office. It later became the office of Dr. Daniel Kingsbury.

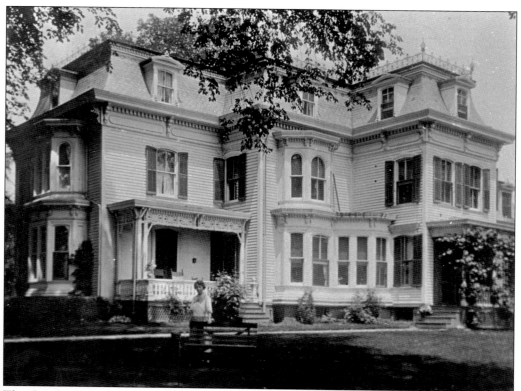

The Goodrich House in 1876 was both statuesque and impressive. On this site, Timothy Hale built a farmhouse, which he gave to his son Atwater. When Atwater died in 1874, his widow, Frances, asked her daughter Deborah and son-in-law John Goodrich to manage the family farm. In this photograph, taken in 1905, Mrs. Charles E. Goodrich (Nellie Griswold) is standing in front of the French Victorian home.

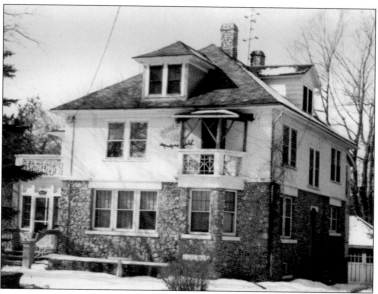

John Jaccoon built this stone house at 2157 Main Street in 1920. He imprinted the name "Glastonbury Villa" above the three front windows. John Scamuzzi, his wife, and two daughters lived there in the mid-1900s. Using rocks and small stones that he gathered nearby, Jaccoon constructed the birdbaths and walls on the property.

# Four

# Business and Industry

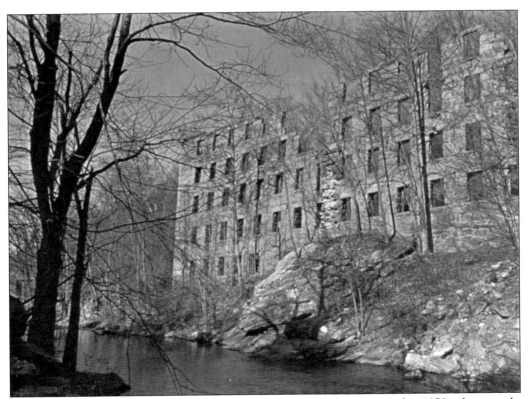

The remnants of the once-prosperous Cotton Hollow Mills are seen in this 1970s photograph. These structures sat downstream from a 50-foot-high dam on Roaring Brook. Today, these ruins look very much the same as in this image, albeit not as tall. They can be seen by taking a lengthy, rather difficult hike from the Grange Pool or an easier path on the south bank of Roaring Brook off Main Street.

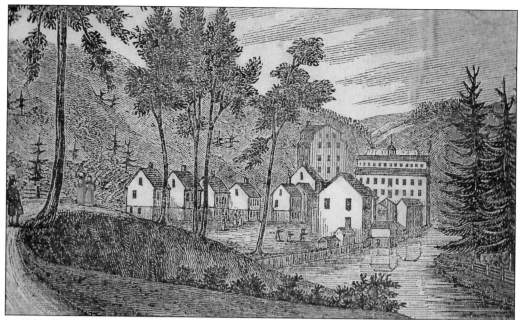

In 1814, the Hartford Manufacturing Company on Roaring Brook in South Glastonbury was one of the largest cotton factories in Connecticut. This 1836 drawing of its Cotton Hollow Mill by John Warner Barbour (1798–1885) is considered by many to be the oldest picture of Glastonbury in existence. In the center of the drawing is a row of small buildings that housed the mill workers.

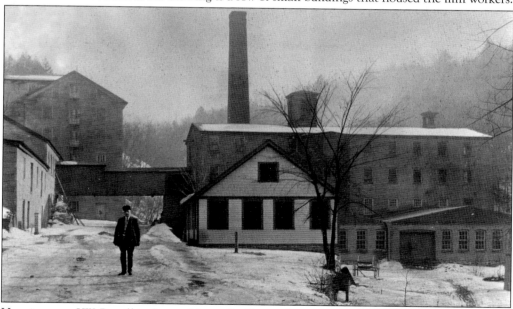

Here is owner J.W. Purtill in front of the mill office in Cotton Hollow about 1916. Born in Ireland in 1847, he moved to Connecticut with his parents in 1850. After attending St. Bonaventure College and working in Manchester, Connecticut, textile mills, Purtill purchased the Wassuc Mills Cotton Hollow factory in Glastonbury and began a successful career as an industrialist. He was also a part-time watchmaker, real estate developer, and church and civic leader.

Two dams, 50 and 24 feet high, provided the waterpower to run the mills of Cotton Hollow. At its peak, the 80-acre site consisted of two major factory buildings, one made of redbrick and one made of stone, and 19 houses in which factory workers lived. In 1820, 15 women, 5 men, and 40 children were employed at the mills. Sixteen years later, there were 130 females and 40 males on the payroll.

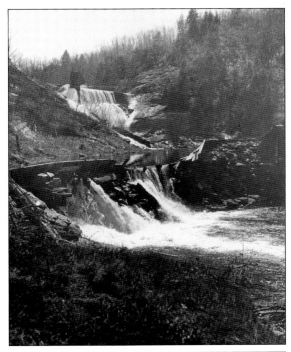

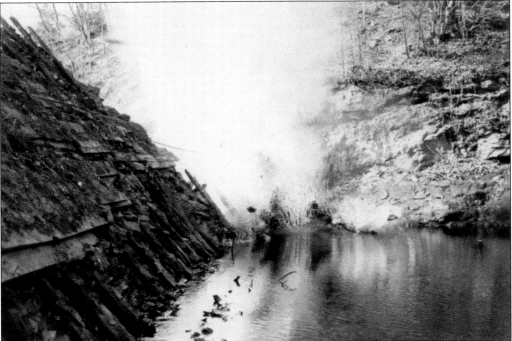

Water sprays in the air as the Hartford Manufacturing Company Dam is blown up on May 10, 1904, creating a surreal scene worthy of Salvador Dali, who happened to be born the next day. The preceding year, the Glastonbury Power Company proposed building a new 100-foot-high dam with a fall of 137 feet. It was believed it would have been the highest dam in New England.

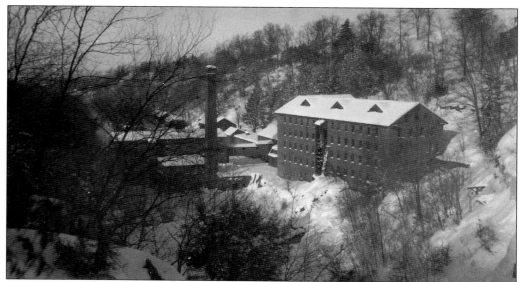

The Hartford Manufacturing Company's mill at South Glastonbury sits covered with snow. Many of the immigrant laborers who came to Glastonbury worked in mills along Roaring Brook during the 18th, 19th, and 20th centuries. The area was accessible to the African American community along Chestnut Hill Road. Also, records show that some African American families owned half-acre lots between Main Street and Coleman Roads.

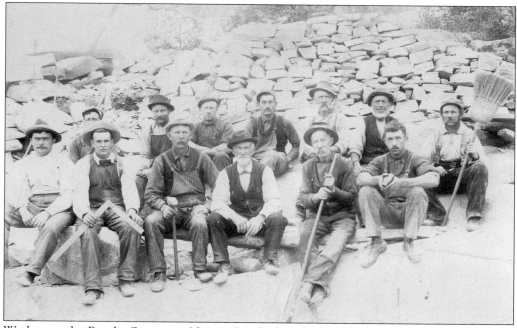

Workers at the Brooks Quarry on Neipsic Road take a break. This quarry operated in the late 19th and early 20th centuries. There have been about 22 quarries in Glastonbury since the first one was established in the 1820s. Although the adjacent town of Portland was better known for its brownstone quarries, Glastonbury granite was used for many Connecticut churches and government buildings.

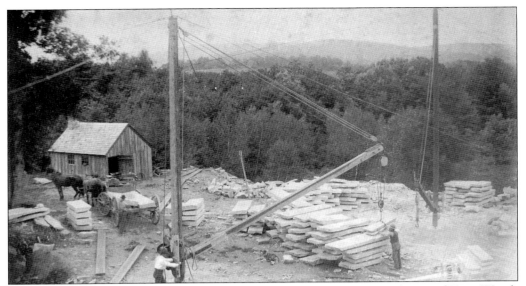

In 1887, workers are loading a wagon at Clark and Hentze stone quarry at the top of Town Woods Hill, now known as Apple Hill. A little over 40 years before this picture was taken, granite from Elijah Sparks Quarry on Weir Street was transported by boat to Hartford for the construction of the Wadsworth Atheneum, the oldest public art museum in the United States.

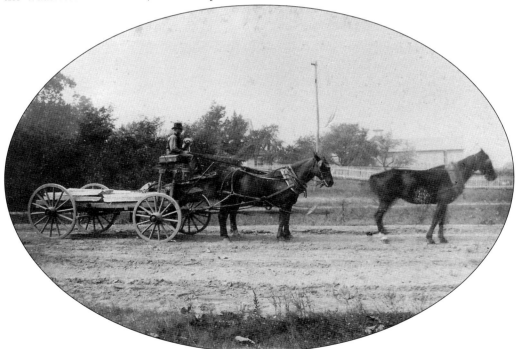

Here, Elisha Clark is seen transporting stone from the Clark and Hentze stone quarry in September 1887. It might have been heading to a barge on the Connecticut River or overland to the nearby towns of East Hartford or Manchester. Some of the town's granite, rich in feldspar, was ground for potters.

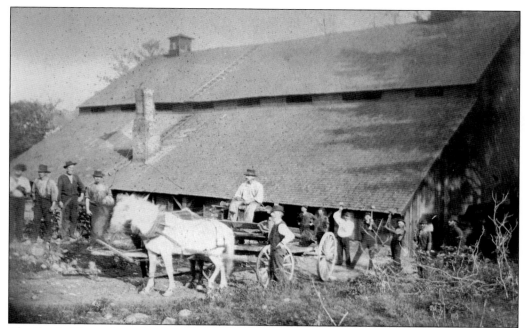

The South Glastonbury Anchor Works, pictured here between 1870 and 1875, made anchors for Connecticut and New York shipbuilders. Built on the north bank of Roaring Brook, the forge was built about 1780 by Robert Hunt. Jedediah Post purchased it in 1841 and hired George Pratt to run it in 1861. Often called Pratt's Forge, it closed in 1891. Today, its location falls within the Cotton Hollow Nature Preserve.

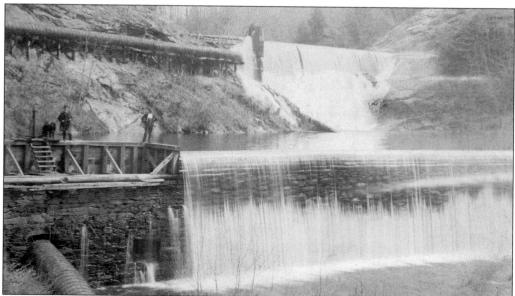

Roaring Brook had enough power to run several large mills throughout the 19th and early 20th centuries. One of its dams, pictured here in 1890, was the Hopewell Mill Dam in South Glastonbury. Booming manufacturing companies contributed to Glastonbury's prosperity and wealth, and this in turn spurred the increase in housing units, churches, stores, and other businesses.

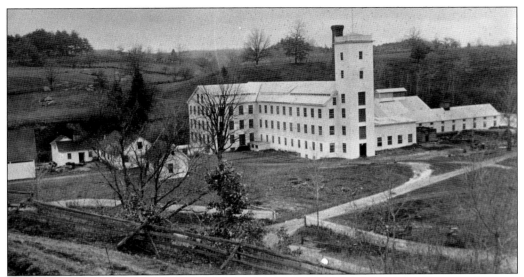

Hopewell Mills was one of the many occupants of this nearly 200-year-old mill site on Roaring Brook near Hopewell and Matson Hill Roads. After Hopewell Mills closed, it was taken over by Glazier Manufacturing Company. In the 1950s, J.T. Slocomb Company, a manufacturer of aircraft parts, purchased the buildings. It closed in 2006. The Town of Glastonbury now owns the property.

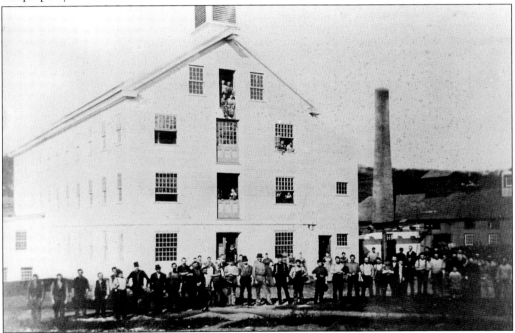

Here are workers at the Glazier Manufacturing Company in 1932. When Amos and Sprowell Dean built the original mill, someone asked what they would call it. One of the brothers said, "I don't know but we'll *hope well* on the mill." After 1909, it was run by Frank Glazier. At the outbreak of World War I, this company enlarged its production facilities in order to manufacture overcoats for Allied troops.

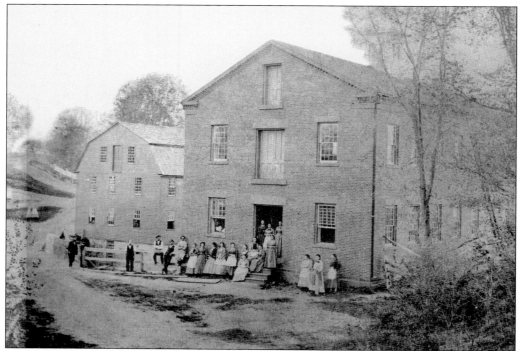

Workers gather outside the door of the Old Addison Mill in 1870. Addison Clarke started the Glastenbury Knitting Company years before the spelling of the town's name was changed. During the Civil War, the company was a leading supplier of undergarments for the Union army. It employed many workers from Germany, Hungary, and Poland. The company provided 400,000 pairs of long johns for US troops in World War I. It went out of business in 1936.

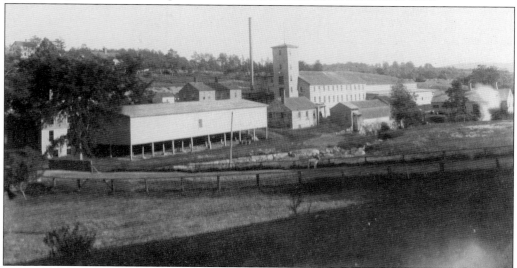

In the 1840s, the Roaring Brook Manufacturing Company built a stone mill at Eastbury Pond. During the Civil War, Edwin Crosby and Sereno Hubbard were running it to manufacture wool products. Since the 1950s, much of the property has been occupied by Quality Name Plate, Inc., a supplier of nameplates for all size businesses.

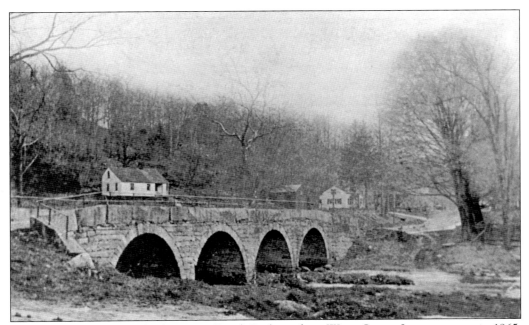

This 1885 view of the arched Roaring Brook Bridge is from Water Street. Just upstream, in 1865, the Roaring Brook Paper Manufacturing Company purchased an old sawmill and started a paper mill to make binder's board for the covers of books. It is said that many of Mark Twain's books were made with its paper products.

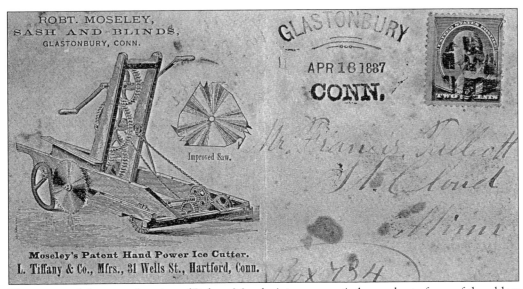

This postcard depicts a drawing of Robert Moseley's ice cutter. A descendant of one of the oldest families in Glastonbury, inventor Moseley received his patent in 1874. In his application, he stated, "By the use of this machine the work of cutting ice is more rapidly performed, and the labor rendered pleasant instead of irksome, as in the old way." Moseley died in 1894.

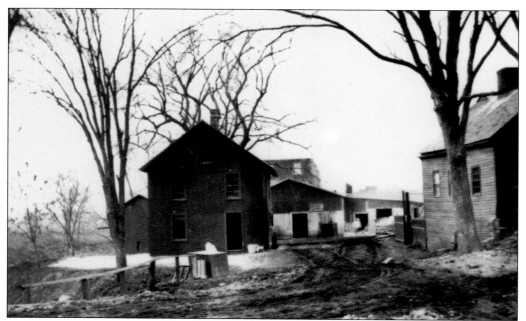

The High Street mill, pictured here in 1905, processed feldspar, a group of rock-forming minerals that make up 60 percent of the earth's crust. In 1905, Louis Howe purchased this mill from the Huspband brothers and bought the old (1866) George Andrews feldspar quarry. During the 23 years he ran the operations, Howe produced between 65,000 and 70,000 tons of feldspar, making him one of the largest producers of feldspar in Connecticut. In 1915, the trolley line was extended down Water Street to transport feldspar from the mill. Between 30 and 60 men worked steam drills at the quarry, while up to two dozen men ran the grinding mill. The finished product was sold to manufacturers of bathroom fixtures, abrasive cleaners, false teeth, and pottery. (Both, courtesy of the collections of the Historical Society of Glastonbury.)

The man in the middle of this picture is Louis Howe, the owner of Howe's feldspar mill on High Street. He was later president of Glastonbury Bank. The man on the left is Herbert Clark, who served the town for 55 years. His posts included assessor, registrar of voters, and the first fire chief of the South Glastonbury fire department. The Herbert T. Clark House senior citizen facility off Williams Road is named for him.

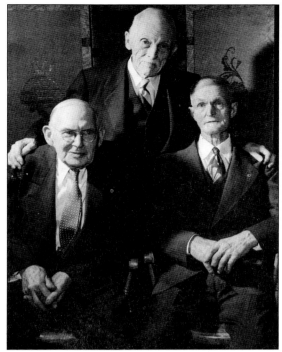

A Glastonbury-Hartford Express Truck Company vehicle appears in this 1914 photograph. Charles Mino is driving, and Bill Mino is standing on the ground. It was around this time that the State of Connecticut first required motor vehicle drivers to obtain licenses. It would be many years before gas-powered transportation would replace horses.

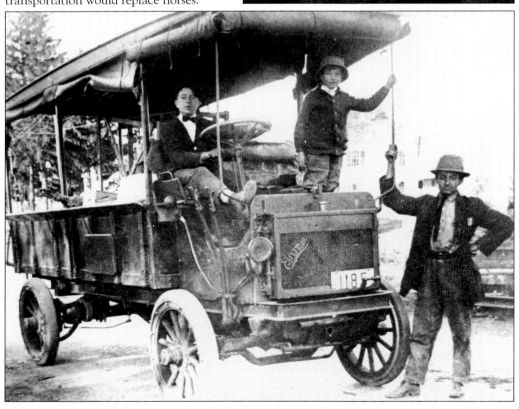

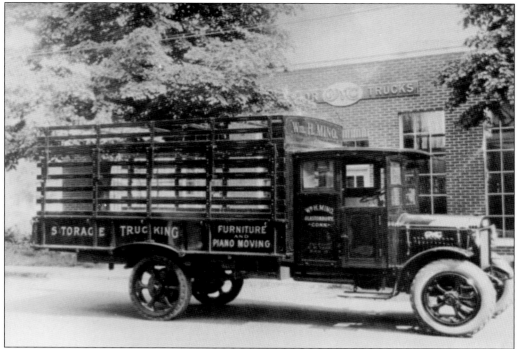

This 1916 open-slatted truck belongs to William H. Mino of Glastonbury and is parked in front of the East Hartford GMC dealership. Its painted sides announced Mino's businesses: storage, trucking, and furniture and piano moving. Later, his son Howard H. Mino became vice president and owner of the family business, Mino Express. Howard retired in 1978 and died in 1998.

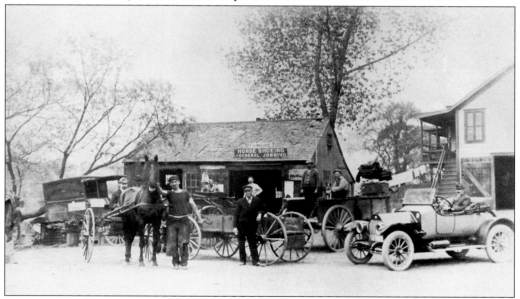

T.H. Moore's Blacksmith shop stood near the corner of Main and Pratt Streets. One wonders if the people in this photograph suspected that automobiles, like the one on the right, would virtually eliminate their trade in a couple decades.

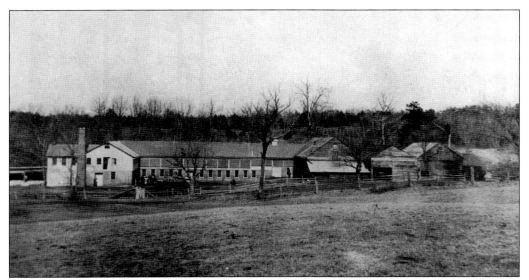

This is Herman Roser's tannery at the corner of Neipsic Road and New London Turnpike in 1893. This picture was taken seven years after Roser (1859–1947) bought the plant from Isaac Broadhead. During World War I, it produced leather for boots and other items for soldiers. The tannery was sold in 1965 to the Allied Kid Company of Boston and closed in 1969. Thomas and James Flanagan later bought the property for use as a machine shop.

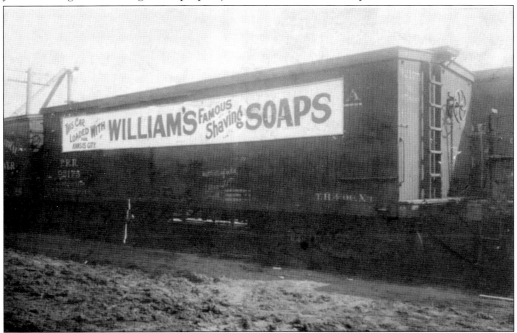

In 1847, at the age of 29, James Baker Williams moved his soap, ink, and shoe-blacking company from Manchester to a gristmill on Hubbard Brook in Glastonbury. During the rest of the century, business expanded until the company's name was known worldwide. Williams died in 1907 at age 88. His family continued to run the company for another 50 years. This photograph shows a train car filled with J.B. Williams products. The company moved to New Jersey in 1960.

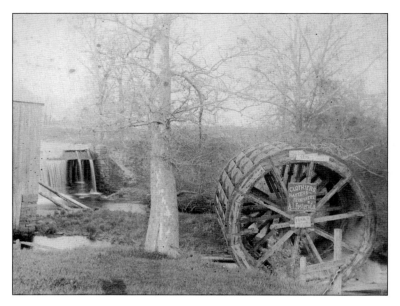

An old waterwheel at the J.B. Williams Co. can be seen in this c. 1900 photograph. The sign tacked on the side of the wheel advertised "Clothiers, Hatters and Furnishers A.L. Foster & Co." The Williams company was well known for its shaving creams, toilet soaps, talcum powder, and other products. Later, its brand names included Aqua Velva and Lectric Shave.

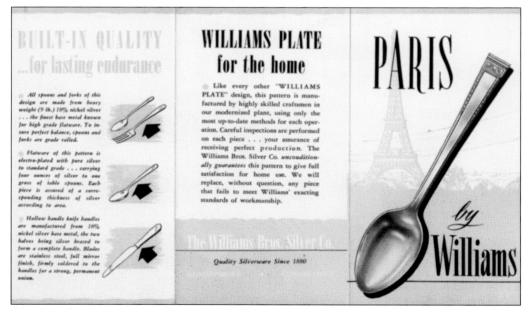

This flyer for silverware was distributed by Glastonbury's Williams Bros. Silver Company, which was located in the Curtisville section of the town near the intersection of Pratt Street and Naubuc Avenue. Founded by J.B. and William Williams in 1880, the Williams Brothers Silver Company was known nationwide for its silver-plated flatware.

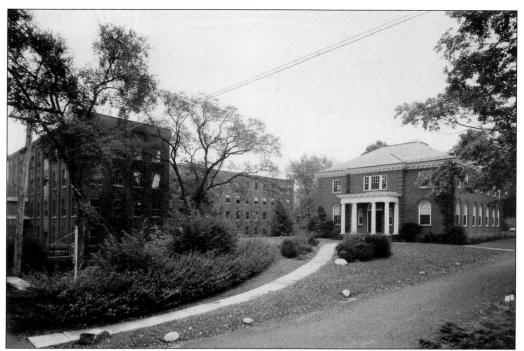

This is the former office building of the J.B. Williams Co. on Williams Street. After the company left Glastonbury, the structure was used for many years as offices for the Glastonbury Board of Education. The remaining part of J.B. Williams's factory complex is now the Soap Factory Condos. Williams Park on Neipsic Street is named for J.B. Williams.

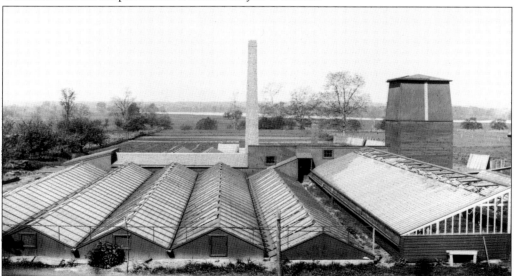

This photograph of Morgan Greenhouses in the Glastonbury Meadows was developed from a c. 1890 glass plate. The white line of the Connecticut River and the coastline of Wethersfield appear across the background. The greenhouses, noted for their winter vegetables, were started by Justus Morgan who died around 1910. Son Oliver took over and ran the operation for many more years.

Before modern refrigeration, many companies produced and stored large blocks of ice cut from lakes and rivers during the winter months. The blocks were stored in large buildings and insulated with sawdust. During the warm months, the blocks were cut into smaller chunks and delivered by ice men, like R.E. Barker of the Hockanum Ice Company, who is pictured here around 1930.

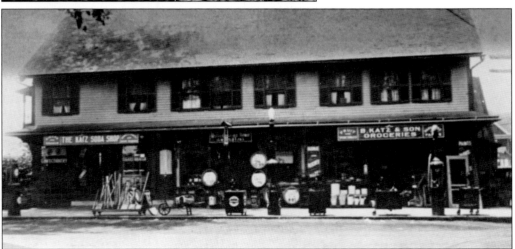

Katz Hardware at 2687 Main Street is one of the oldest businesses in Glastonbury. Benjamin Katz bought the building from Frank Lee in 1920. Selling more than just hardware in this 1920s photograph, the business boasted a soda shop on the left, an automobile shop in the middle, and a grocery store on the right. In 1955, Ben's grandson Dick converted the establishment into a hardware store, and it is still operating today.

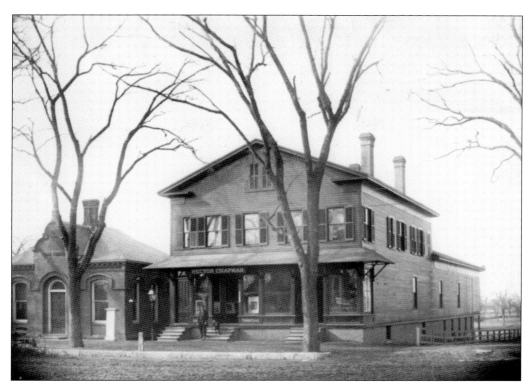

Hector Chapman's furniture store, which was destroyed by a fire in 1917, occupies most of this photograph. Franklin's Pharmacy, housed in a two-story brick building that is now occupied by Daybreak Coffee, replaced it. To its left is the town records building, erected in 1881 in response to a state legislature requirement that towns provide protection for public records.

This June 1929 tally of goods purchased from F.S. Gaines Groceries and Grain includes hay, oil, flour, salt, and meal. In several months, these prices would begin to change as the stock market crashed and the Great Depression loomed ahead.

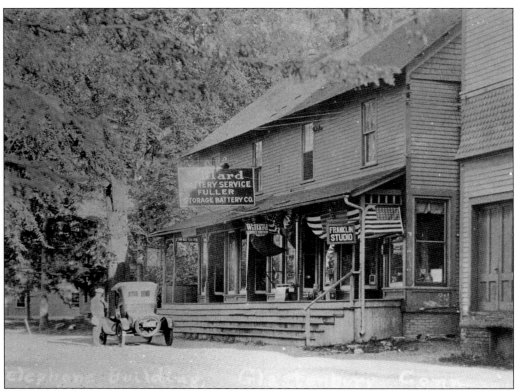

Adjacent to the Franklin Studio on Hebron Avenue, the Fuller Storage Battery Company offered Willard Battery Service to car owners. Customers could have their automobile batteries repaired and recharged, or, as a last resort, replaced. This photograph was taken in 1922, well before the days of long-lasting, disposable car batteries.

On New London Turnpike in 1922, this building housed the Glastonbury Department Store and the Power and Light Company offices. The Odd Fellows hall was on the second floor. A building "for all seasons," it previously provided a home for Olcott's Grocery Store, the post office, the telephone exchange, and the public library. The building was demolished in 1976.

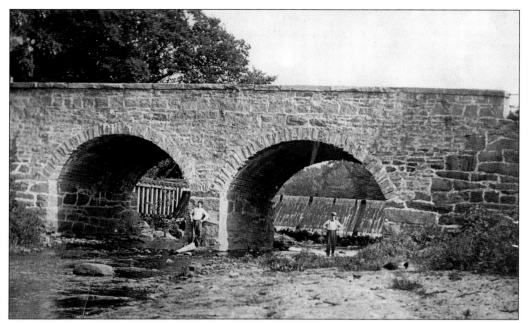

Two men pose for photographs under the Spar Mill Bridge at Tryon Street. Constructed in 1904 by Justice of the Peace Hartwell Brainard and John Taylor using granite from Glastonbury quarries, it spanned Roaring Brook. Although Roaring Brook was the most popular location for Glastonbury's industry, Salmon Brook in the northern section of the town hosted a sawmill, a felt hat factory, and a casting works.

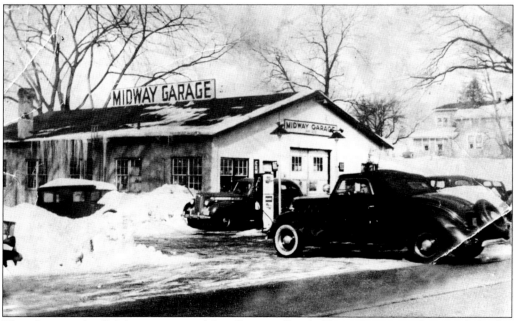

This photograph of Midway garage on Main Street in South Glastonbury was taken in 1946. This building was formerly the factory of aircraft manufacturer Harriman Motors and is still standing. Part of the name "Harriman Motors" is still visible over the front doorway.

Inventor Frank Herbert "Bert" Harriman used a wooden building on Main Street in South Glastonbury, which was erected around 1910 and torn down in 1932, to manufacture his airplanes. The building pictured here replaced it. Harriman Motors is often cited as Connecticut's first commercial airplane manufacturer. Perhaps the only existing example of one of his aircraft engines, a four cylinder one, is in the collection of the New England Air Museum in Windsor Locks, Connecticut.

A native of Maine, Bert Harriman worked at Thomas Edison's labs in Menlo Park, New Jersey, in his 20s. His next job was with Hartford Hospital where he developed an arc light. He sold it to General Electric and used the $10,000 he received to found a firm for making marine motors. He began the manufacture of airplanes and airplane engines only seven years after the Wright brothers' first successful flight in 1903.

Bert Harriman's wife, Bertha, and their daughter Gladys are captured in this photograph. One story has it that Bertha donated the family silverware to Bert's efforts to coat his airplane engine bearings with silver to prevent overheating. It is said that years later, other manufacturers copied Harriman's silver procedures. Although he was one of the first in the industry, Wilbur and Orville Wright had already received patents on most basic airplane innovations, leaving other pioneers, like Harriman, in second place.

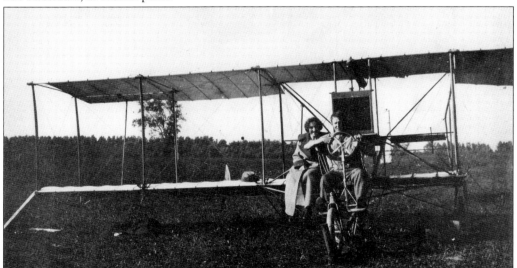

Here, Carl Hollister and a friend try out a Harriman plane. The first airplane flown by Bert Harriman in Glastonbury crashed. Later, after he perfected his machines, he went on to give demonstrations of his aircraft at air shows. Harriman experimented on biplanes, triplanes, and seaplanes.

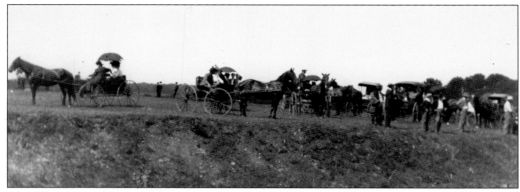

The Glastonbury Racetrack was located east of Main Street on Pinney property by Talcott and Woodbridge Roads. Ralph Pinney constructed the half-mile, oval horse racing and exercising track on his farm in the 1880s. The racehorses included trotters and pacers. They often pulled sulkies and even buckboards. In 1951, the State of Connecticut Highway Department took part of the track when it moved Route 17. Three years later, developers constructed Woodbridge Estates on the site.

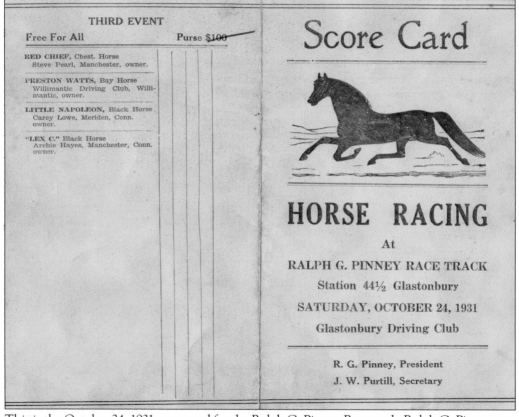

This is the October 24, 1931, scorecard for the Ralph G. Pinney Racetrack. Ralph G. Pinney was president, and J.W. Purtill was secretary. The traditional award for the Fall Race Meet was 100 bushels of oats to be divided among the winners. At its peak, the Glastonbury Driving Club had more than 150 members.

# *Five*

# SPIRITUAL LIFE

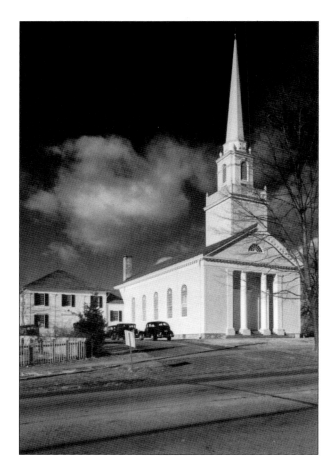

First Church of Christ stands
tall and elegant in the sunlight
in 1941. This is the church's fifth
building and third location. The
first minister, Timothy Stevens,
was installed in October 1693.
Churches in the 1600s were
unheated, and sermons were one to
three hours long. During prayers,
which lasted about half an hour
to an hour, the people stood.

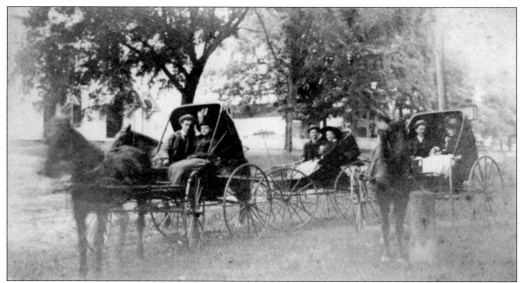

People dressed in their Sunday best to attend services at the First Church of Christ on August 31, 1887. Many Protestant and Catholic churches have been built in Glastonbury. Most Jewish residents were members of congregations in nearby towns until Congregation Kol Havarim was founded in 1984. The congregation affiliated with the Reform Movement and dedicated Glastonbury's first synagogue in 1987.

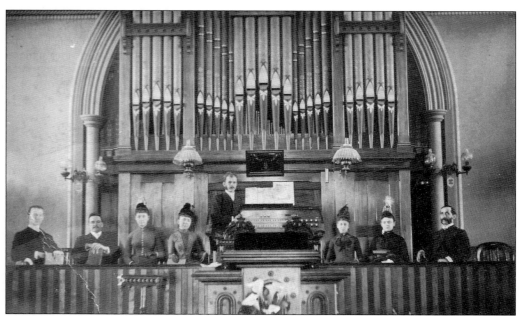

Here is the First Church of Christ's choir on March 24, 1889. Deacon George Plummer, who was leader of the choir for more than 40 years and a deacon for 45 years, was also treasurer for many years. It was his custom, if the church finances showed a deficit at the annual meeting, to withdraw money from his pocket and state, "Here is half the sum needed. Brethren, will you make up the rest?" They always did.

The East Glastonbury Methodist Ladies Aid Society is shown having its picture taken at the home of Doctor Gilwack and his wife in Rockville, Connecticut, in 1891. From left to right are (first row) Belle Gilwack, Winifred (Weir) Nolan, Ruby (Weir) Ranney, Clifford Weir, Annie Gilwack, and Doctor Gilwack; (second row) Ada Gordon and Mary Hale.

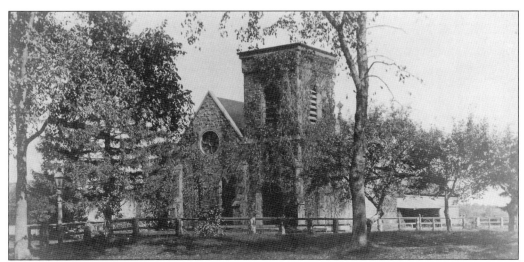

St. James Episcopal Church is shown here around 1900. Residents in north Glastonbury decided to establish their own Episcopal church in 1857. Two years later, the cornerstone was laid. Samuel Hall of Portland was its first rector. The church was built of stone donated by a Portland quarry and was transported by ox carts on land and by scows up the Connecticut River. Aristobulus Brainard of East Glastonbury constructed the stonework on the church. In 1904, a fire ravaged the church.

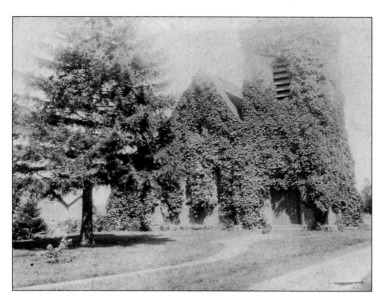

St. James Episcopal Church with a full growth of ivy was a sight to behold when the ivy was in bloom. In the disastrous 1904 fire, everything inside the building with the exception of communion service pieces was lost. Only the tower survived intact due to the diligence of the volunteer fire department, despite the absence of fire hydrants or adequate hoses. The church was rebuilt from Portland brownstone.

In 1904, the interior of the First Congregational Church in South Glastonbury is decorated for the Easter service. From their founding until this time, Glastonbury's Congregational churches supplied a number of missionaries. These included L.R. Scudder, a missionary physician in India, and Ezekiel Skinner, a Baptist doctor and preacher in Liberia. A number of the church's women members served as missionaries. These included Kitty Scudder (India), Virginia Hale (Africa), and Mary and Martha Williams (Spain).

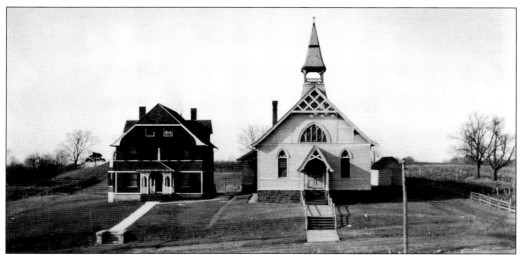

St. Augustine's Catholic Church and rectory on Hopewell Road in South Glastonbury can be viewed in this photograph, which was taken around 1904. Two years earlier, Bishop Michael Tierney assigned Fr. Francis Murray to be its pastor when it was established as a parish for Irish and Italian families working and living in Glastonbury. The church pictured above was dedicated in 1878 when it was still a mission church of St. Mary's Church of East Hartford.

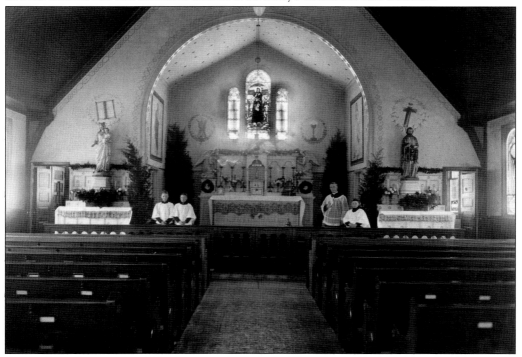

Pictured are the interior of St. Augustine's Catholic Church, along with three altar boys and a priest. While Catholics of South Glastonbury attended this nearby church, the northern sections of the town had St. Paul's Church. When the expanding population of East Glastonbury needed a parish close to it, St. Dunstan's Catholic Church was built in 1974. St. Dunstan was named after a 10th-century abbot of Glastonbury, England.

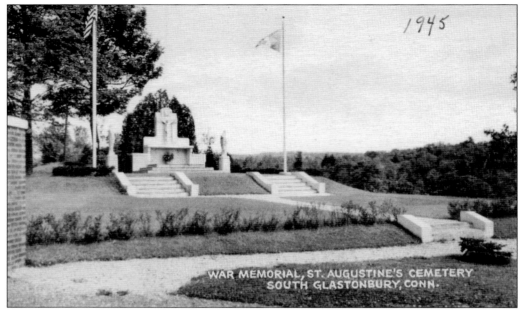

This postcard shows the war memorial in St. Augustine's Cemetery shortly after its dedication in 1945. In November 1906, four acres east of the church on Hopewell Road were deeded by the Purtill family to St. Augustine's for use as a cemetery.

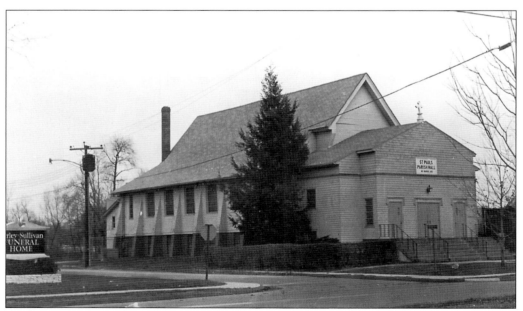

Prior to 1950, St. Paul's Roman Catholic Church was located on Naubuc Avenue. Fr. Francis Murphy was pastor during its construction. This building was used from the early 1900s to 1958, when a new St. Paul's was built on Main Street. The old church was converted into a parish hall. Farley-Sullivan Funeral Home appears on the left in the above photograph.

The cupola of the new St. Paul's is being lifted into place in 1958. The Colonial structure was designed by Walter R. Furey of Thompsonville. With a capacity of 600 people, it is 53 feet wide and 139 feet long. The Associated Construction Company of Hartford was the builder. (Courtesy of St. Paul's Roman Catholic Church.)

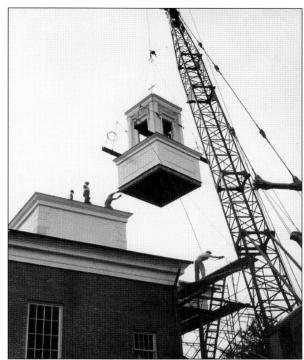

St. Paul's is at 2577 Main Street. The finished church included an attached 50-by-81-foot wing that could seat 300 people. Today, St. Paul's is linked with St. Augustine's in South Glastonbury and shares the same clergy and some staff members. (Courtesy of St. Paul's Roman Catholic Church.)

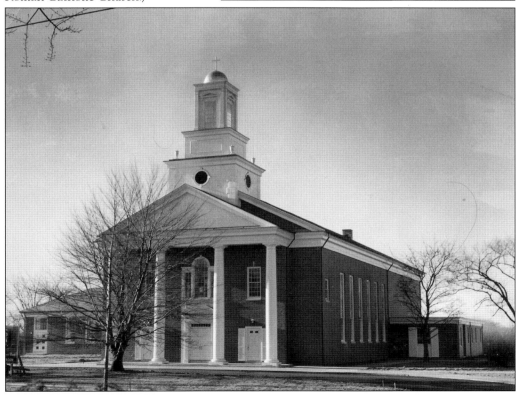

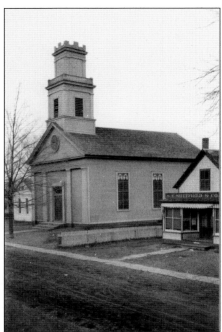

Pictured are, from left to right, the Sixth District schoolhouse, the South Congregational Church, and Sheffield's General Store in about 1910. The school was torn down in 1922, and the church was rotated in the 1960s to face Main Street. Currently, this is the oldest Congregational church in town since the other two Congregational churches needed to be rebuilt after the 1938 hurricane.

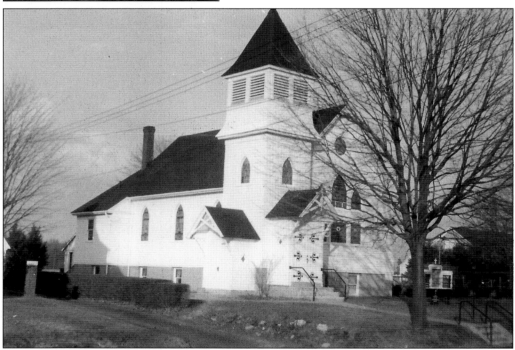

This is a 1929 photograph of the Lutheran Church of St. Mark. In the early 1880s, the Kiedasch family found a German-speaking minister for Glastonbury and in 1902 established the first Lutheran Church of St. Mark on Grove Street. In 1925, the community moved to a new church on Griswold Street. In 1972, that building became a parish hall as a third edifice was erected next door.

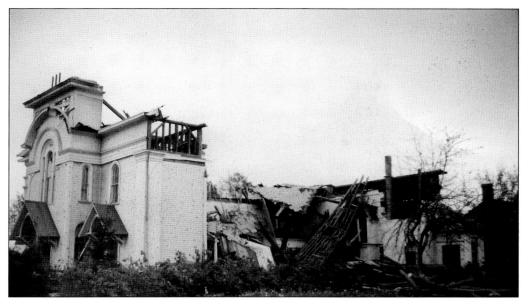

Here is the First Church of Christ on September 21, 1938, after Connecticut's "Hurricane of the Century" swept through Glastonbury's Main Street. This building had been constructed in 1867 to replace its predecessor, which was destroyed by fire the previous year. Today's First Church building, with modern synthetic siding, was dedicated in 1940.

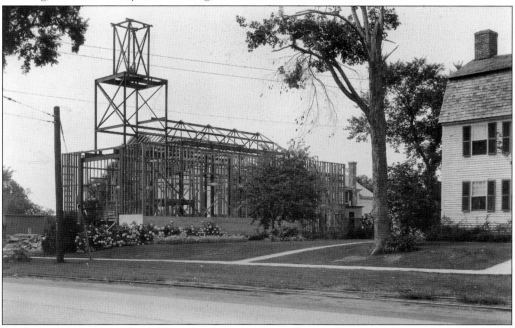

This picture of First Church's rebuilding was taken in August 1939. Both this church and the Buckingham Congregational Church were so badly damaged by the 1938 hurricane that they needed to be rebuilt from the ground up. While these churches were being crushed by the hurricane winds, hundreds of majestic elm and maple trees along Main Street were uprooted, radically changing the appearance of the heart of the town.

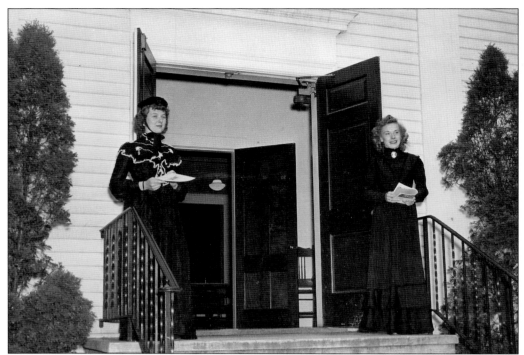

Mitzi Moore and Jean Purtill stand at the door of the First Church's social hall in 1948. Things were not always so peaceful in town. In April 1775, news of the fight in Lexington, Massachusetts, between local citizens and the British forces reached First Church's Rev. John Eells as he was preaching. He described the facts to the congregation, and they spent the day preparing their firearms and casting musket balls. These patriots left for Boston the next morning.

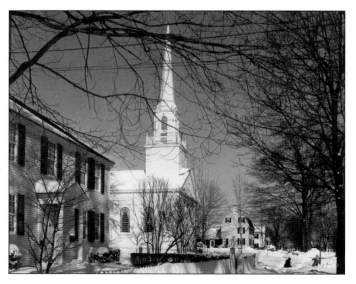

The scores of well-maintained ancient buildings make Main Street one of the most attractive thoroughfares in Connecticut. From left to right are the Hale House, the First Church, and the Benton House. Today, the Federal-style Benton house at 2195 Main Street is home to the attractive Connecticut River Valley Inn. The ell in the rear of the house was built around 1740. The main section was built in 1800 for Samuel Benton and Fanny Talcott's wedding.

# Six

# EDUCATION

Here are students at Glastonbury High School around 1912. At about this time, Emma Tillman (not pictured) was one of the school's students. Almost 100 years later, on January 28, 2007, when she died at age 114, she was the oldest validated living person in the world. The daughter of former slaves, she moved with her family to the Hartford area in 1900. She attended Glastonbury High School where her courses included English, algebra, English history, civics, and commercial arithmetic.

Mary Kingsbury (1865–1958), the daughter of Dr. Daniel Kingsbury, was a graduate of the Glastonbury Free Academy. In the early 1890s, she became a teacher at the school. In 1900, she was recommended for the librarian position at Brooklyn's Erasmus Hall High School. She passed the first examination ever given by the New York Board of Education for a librarian position and became the first professional school librarian in the country.

These students pose for a class picture at the First District School at the corner of Main and Pratt Streets around 1912. Dorothy Douglas is the girl in the checkered dress in the upper right corner. Until 1906, Glastonbury had 18 autonomous school districts. Today, Glastonbury has six elementary schools, one sixth-grade school, one seventh-and-eighth-grade school, and one high school.

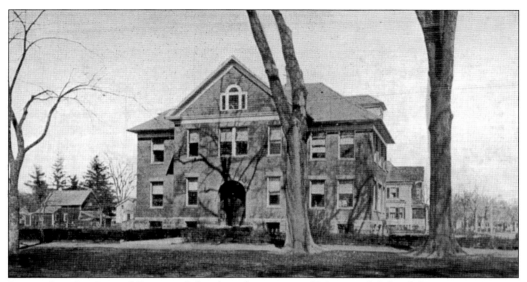

Pictured is the Second District School at the corner of Main and School Streets in 1913. In 1906, it replaced an older school on the same spot and was used until 1930, when it became the Glastonbury Town Hall. A few years before this photograph was taken, the town had 18 little schoolhouses holding grades one to eight. In the 1930s, some were closed as it became feasible to transport pupils by bus to larger, central schools.

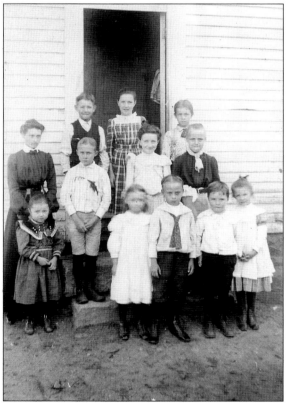

This class photograph of the Seventh District School (Taylortown School) around the 1890s memorializes 11 students of various ages with their teacher. This school was located on Main Street in the Taylortown section of town south of Roaring Brook. Near the Portland line, the Taylortown section was first settled, appropriately enough, by the Taylor family. The original school was built on Azariah Taylor's property around 1790. A new school was erected in 1853.

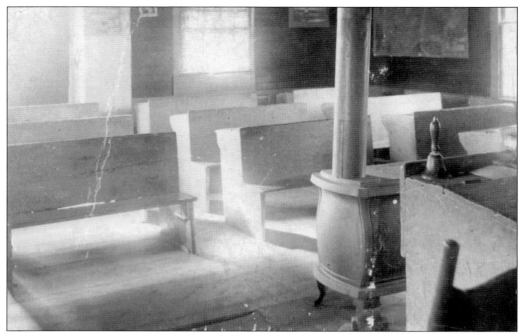

Rigid wooden benches, a potbelly stove for heat, and the teacher's podium with its bell handy to signal students that playtime is over can be viewed in this interior scene of the Seventh District School (Taylortown School) in 1897. Amy Griswold Grant was the teacher. This school, like most in town at the time, had one teacher for six grades. It never had running water or an indoor toilet.

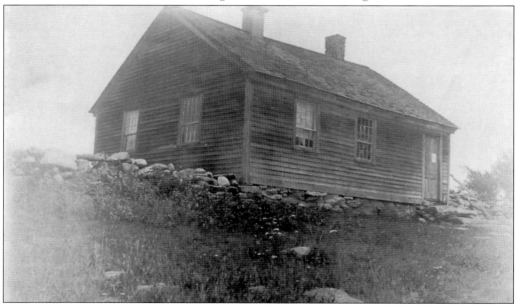

The Eighth District School (Matson Hill School) was located at Matson Hill Road and Woodland Street. This photograph was taken in 1900. Mary K. Curran, a 1903 graduate of the Glastonbury Free Academy, was a teacher in Glastonbury for 43 years. Most of those years were spent at the Eighth District School.

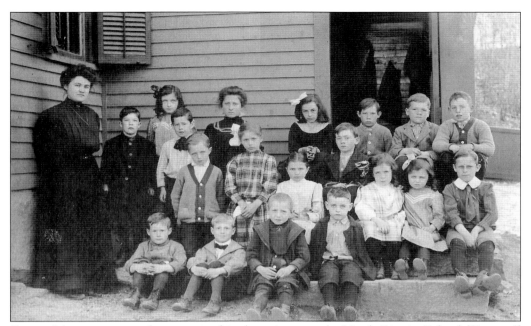

Some of the younger pupils appear in this class picture at the Ninth District School (Hopewell School) in an undated photograph. About a dozen boys dressed in their knickers and a smaller number of girls in their mandatory dresses are grouped outside this open-shuttered school. In 1906, this school educated 69 pupils, ranging in age from four to 15.

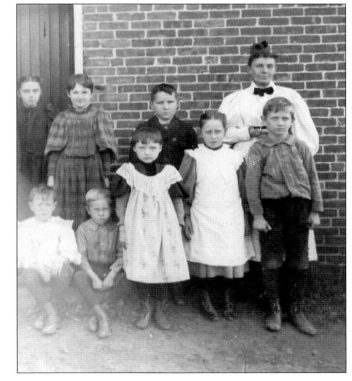

Pictured here are some of the students who were enrolled in the Tenth District School (Nayaug or Tryon Street School) in South Glastonbury. The teacher here is Harriet Caswell Miller. For the school year 1889–1890, the school had 11 students, the wage for its one teacher was $228.50, and the cost for fuel and incidentals was $21.50.

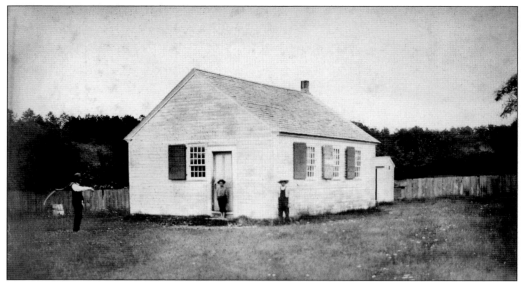

Here is the 11th District School (Howe Street School) in 1860. It was located next to Hurlburt's house. In this photograph, Hanford Stowe holds the scythe. This one-room schoolhouse probably had fewer students at this time than in 1906 when it recorded 25 children, ages four to 14. Two of the 14-year-old girls of that year also worked at the Addison Mill.

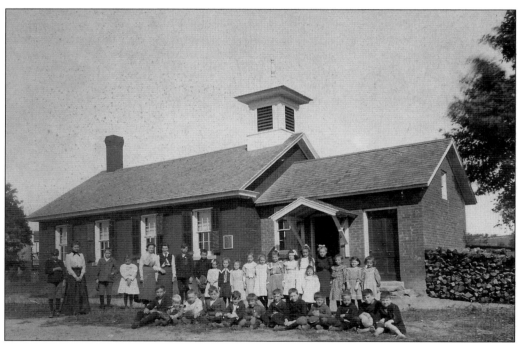

The 12th District School (Wassuc School) appears in this c. 1902 photograph. This school was built around 1840 to accommodate the families that settled in eastern Glastonbury in the first part of the 19th century. When this school closed in 1940, it had only 10 students, all boys. Back in 1906, it boasted 33 students, ranging in age from five to 15. Today, this building is a private home.

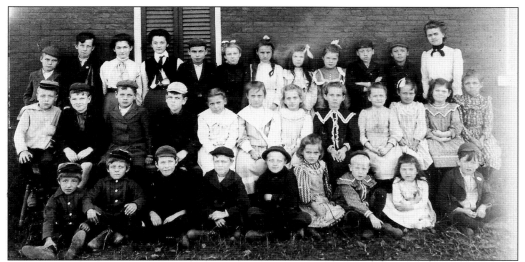

More than 30 pupils at the 12th District School (Wassuc School) are in this 1902 photograph. From left to right are (first row) John Carini, Joe Carini, Bert Trowbridge, Sam Granger, Frank Pfair, Nellie Bemont, William Ludwig, Gladys Bailey, and Elmer Thompson; (second row) George Dailey, Roy Dailey, Shurmont Hollister, Ray Dailey, Delia Royal, Mary Tearney, Bessie Bemont, Jessie Bemont, Ida Bailey, Gladys Ruoff, Ana Dailey, and Louise Carini; (third row) Emory Hollister, William Trowbridge, Nellie Murray, Mary Shifman, Emil Royal, Daisy Dutton, Elizabeth Granger, Ina Dailey, Gertrude Hollister, Albert Dailey, Alfred Lavalette, and teacher Bessie Brainard Bell.

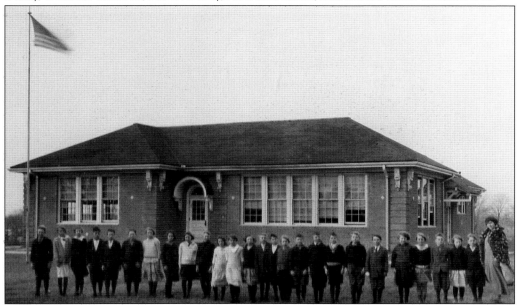

Students of the 18th District School stand by the Hubbard Street School around 1923. Standing, from left to right, are Tony Kuszai, Alice Polapek, Gertrude Shaft, William Blazensky, Joe Kuszai, Peter Kauset, Kathleen Anderson, Dorothy Alensky, Irene Ulrich, Albert Blazensky, Dorothy Blessing, Catherine Sycz, Isabelle McKeown, Joe Sycz, Robert Blazensky, Mamie Kuszai, Richard Handel, Hamilton McKeown, Clinton Islieb, Chester Alexander, Juli Dolenga, Helen Wilk, Annie Anderson, and R. Bidwell.

This 1890 photograph looks south on Main Street from the First Church's steeple. The building in the center is the Glastonbury Academy. Begun as the Glastonbury Academy in 1870 with 43 men and 50 women, it became the Glastonbury Free Academy in 1938. The house with three chimneys in the foreground of this picture is at 2163 Main Street.

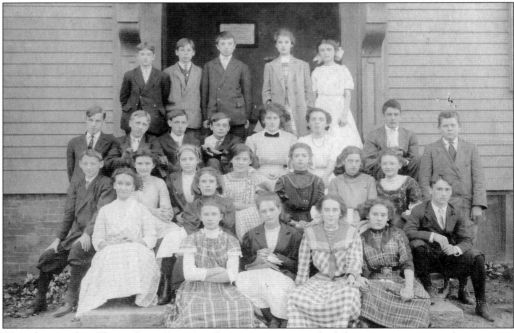

The class at the Glastonbury Free Academy was composed of these young men and women in the early 1900s. The town has always been known for its quality education. Dictionary pioneer Noah Webster's first job after graduating from Yale College was to teach in Glastonbury during the 1778–1779 school year.

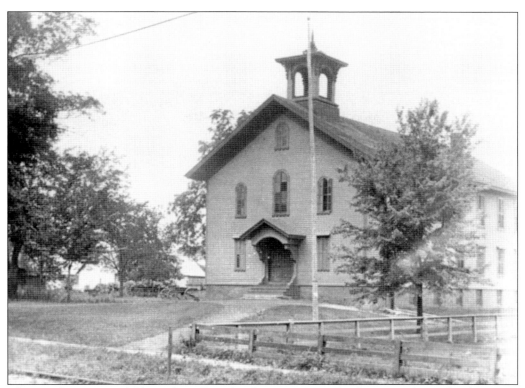

This is a front view of Glastonbury Free Academy in 1938. The first secondary school in town had been the tuition-charging Glastonbury Seminary, founded in 1796 and closed in 1845 when its building burned down. Another private school, the Glastonbury Academy, began operation in 1870. In 1890, it received monetary support from individual donors and converted to the tuition-free school seen in this photograph.

In 1901, the town voted to create a public high school. The high school moved into a new building on the site of the Glastonbury Academy in 1922. This photograph was taken around 1925. The school cost $150,000 to build. Four years later, an addition was constructed at a cost of $25,000. In 1890, the annual cost to the town for all 18 schools was $6,100.

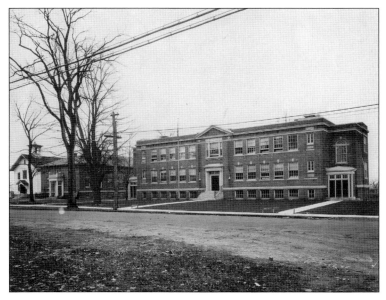

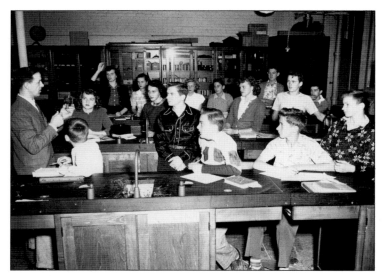

This 1948 chemistry class at Glastonbury High School has students listening intently to a lecture by teacher Peter Netupsky. The high school stayed in this 1922 building until 1953, when the present high school was constructed on Hubbard Street. The cost for the 1953 building, designed to house grades seven and eight, as well as the high school, was about $1.5 million.

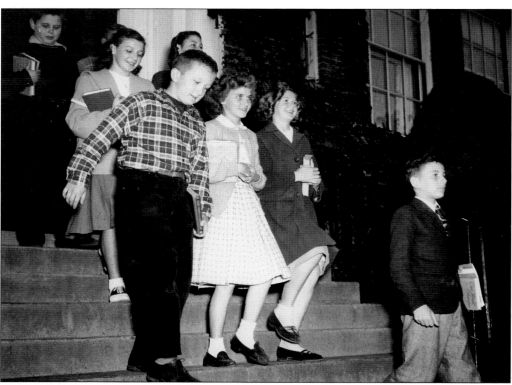

In 1948, smiling seventh-grade students walk down the steps after leaving an assembly at Glastonbury High School. Seen are the top step is Barry Elliot; on the second step is Jean Lanieri; on the third step are John Ruff, Mary Halun, and Pat Morrissey; and on the bottom step is Murray Varat. This building served as the town's four-year high school until a new six-year junior-senior high school was built in 1953.

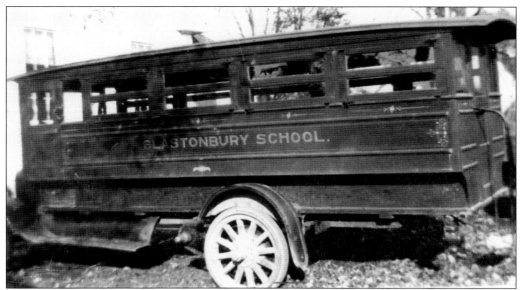

Glastonbury's first motorized school bus was this 1917 chain-drive Ford. At 52 square miles, Glastonbury is one of the largest towns in the state. In the 19th and early 20th centuries, the logistical problem of getting the dispersed population of children to school was solved by creating 18 small schools spread throughout the town. Today, with fewer schools and a far greater population, an extensive school transportation service is required.

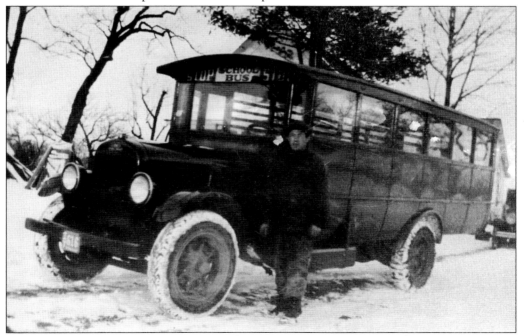

A Glastonbury school bus is frozen in time during a typical, snowy, New England winter day. This 1917 Ford was the first motorized school bus to serve the town. Joe Arrigoni, the driver who is standing next to the bus, was in charge of getting the students safely from the John Tom Hill area to Glastonbury High School. This photograph was taken during the 1918–1919 school year.

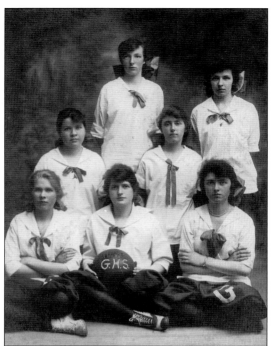

The young lady holding the basketball in this March 3, 1914, photograph was Dorothy Douglas, who played right forward. Other team members included Patty Williams (left forward), Edith Williams (center), Arline Talcott (right guard), and Alice Purcell (left guard). In May 1920, Dorothy, daughter of retired highway contractor Arthur Douglas, married Chester Hale at Glastonbury's First Congregational Church.

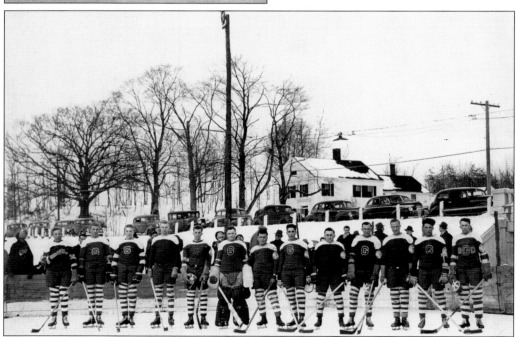

Members of the Glastonbury Blue Devils Hockey Team were, from left to right, Hub Pfau, Don Ramaker, Bob Ramaker, Jud Ramaker, Everett Stino, Verne Johnson (goalie), Tris Taylor, Ted Tyrol, Dink Murray, Smokey Woods, Bud Tryon, Frank Ottone, and Lee Johnson. In the late 1930s, Lloyd Holland offered his property next to the Old Cider Mill, volunteers built an ice rink, and the Blue Devils team became its main attraction.

## Seven

# LAND AND FARMS

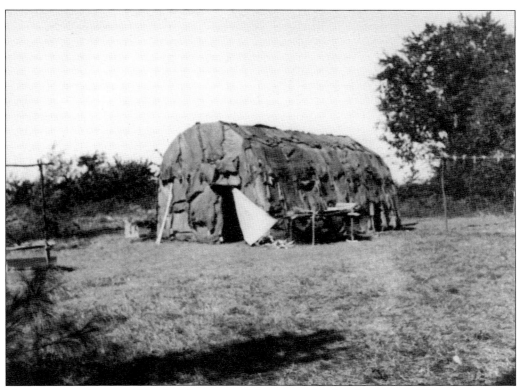

Here is a view that would be familiar to pre-17th-century Native Americans. When the English settlers arrived, members of local tribes lived in clans of about 100 people. In the summer, as pictured in this photograph, they would live in round wigwams and longhouses along the river. As temperatures became colder, they moved inland to the hills and lived in rock shelters facing south or west.

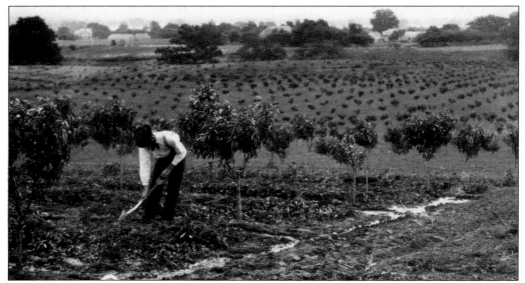

An example of irrigation is seen here at the Hale orchards. At the time of his death in 1917, J.H. Hale was the sole owner of J.H. Hale's Nursery and Fruit Farms in Glastonbury, president of the Hale Georgia Orchard Company of Fort Valley in central Georgia, and president of the Hale and Coleman Orchard Company in Seymour, Connecticut. Together, the three orchards contained 3,000 acres of cultivated fruit trees.

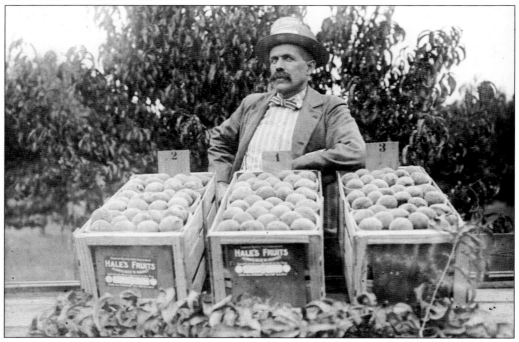

John Howard "J.H." Hale, who was known as the "Peach King" throughout the United States, is pictured here in 1913. He started working seven days a week on a New Britain farm at age 14 for $12.50 per month. He used much of his savings to buy fruit trees. At the end of his life, he owned one of the largest fruit businesses in the country.

J.H. Hale and his daughter Laura Hale Gorton Tiger (1897–1953) relax by a heavily laden fruit tree during the harvest season. At the end of the 19th century, J.H. helped found the Connecticut Agricultural College, which in 1939 was given its current name, the University of Connecticut. Laura later became a prominent realtor and was instrumental in developing Glastonbury's suburban character.

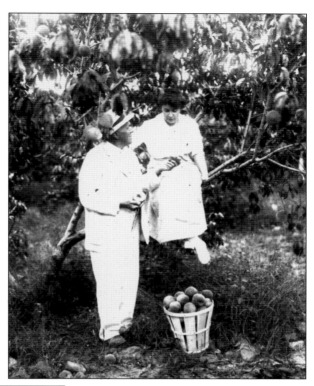

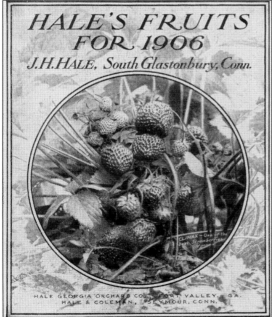

An example of literature distributed by J.H. Hale's company is shown here. J.H. became the first American orchardist to sort fruit by grade. He also was a pioneer in shipping his products over long distances in refrigerated railroad cars. Active in his community, he was instrumental in the establishment of the Glastonbury Grange and he served as a master of the state Grange.

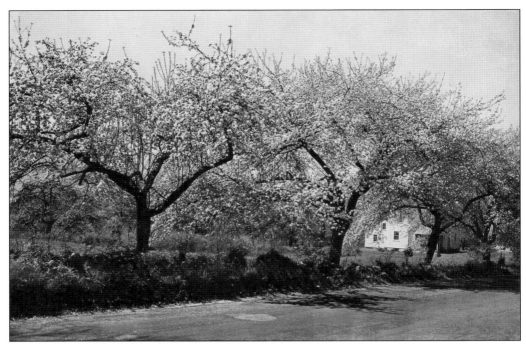

Apple trees are in bloom on Matson Hill in 1936. The environmental conditions in Glastonbury that allowed J.H. Hale to succeed with his peaches also allowed many others to establish their own orchards in town, both large and small. Especially noteworthy were the early-20th-century Italian immigrants who were specialists at managing hillside orchards.

These men stopped collecting hay for a moment to pose for this c. 1900 photograph. Agriculture has been an important part of Glastonbury life since the pre-17th century when Native American tribes raised corn, beans, pumpkins, and squash. Sales of acreage of Glastonbury Meadows were especially brisk whenever the price of hay rose substantially.

The 12-acre Great Pond looks serene in this 1904 winter photograph. Located between Main Street/Route 17 and Tryon Street in South Glastonbury, it is now the centerpiece of a 70-acre nature preserve. The Great Pond Preserve includes a blue-blaze "Pond Trail" that goes past the largest Red Cedar tree in New England. A 15,000-year-old glacial dam surrounds the preserve.

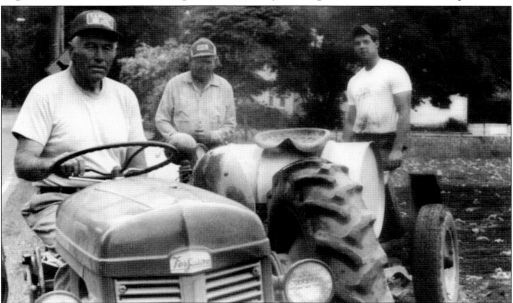

From left to right are fifth- and sixth-generation Glastonbury farmers Howard Horton Jr., Kenny Horton, and Ken Horton. Their meticulously maintained family farm has been a landmark of the Nayaug section of South Glastonbury since the 1860s. It specializes in broadleaf tobacco and tomatoes. Part of Billy Joel's 1993 "The River of Dreams" music video was filmed on the Horton farm.

The c. 1908 scenes on this page would be familiar to Italian-born Frank Saglio. Around this time, he moved to Glastonbury and became a foreman at Hale Orchards. In 1917, he started his own 100-acre fruit and vegetable farm on John Tom Hill. His son Henry became interested in raising chickens. He hired a geneticist in 1940 and began developing breeding chickens for his company, Arbor Acres Chicken Farm. His birds—which were meatier, reached maturity quickly, and laid more eggs—were largely responsible for chicken becoming inexpensive meat. By 1960, one-half of all chickens consumed in the world came from Arbor Acres's breeding stock. In his 80s, Saglio started a new company dedicated to producing antibiotic-free chickens. Henry Saglio, who Frank Perdue called, "The father of the poultry industry," died in 2003 at age 92. (Both, courtesy of the collections of the Historical Society of Glastonbury.)

*Eight*

# ORGANIZATIONS

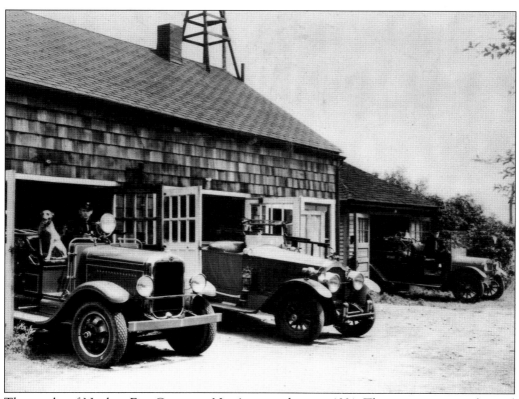

The trucks of Naubuc Fire Company No. 1 appear here in 1931. The equipment was housed at the rear of 256 Naubuc Avenue behind Chief Muccio's house. He was chief of the Naubuc Department for two years before Glastonbury's three fire departments were reorganized, and he became chief for the town.

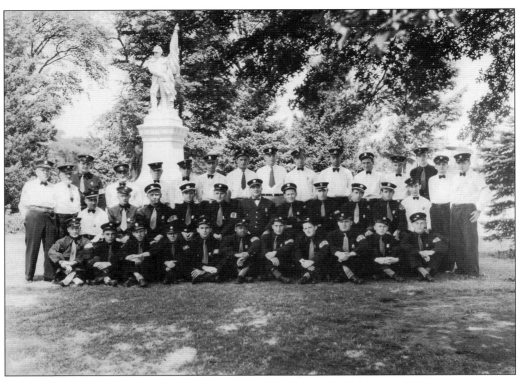

Members of the Glastonbury Volunteer Fire Department are pictured in the above 1930s photograph. From left to right are (first row) Stanley LaFargue, Andrew Motowidlak, Rudolph Drusbacky, Jim Curran, Joseph Pudlo, Henry Tilley, Edward Faber, William Wierdak, Stanley Oberz, Arthur Dickau, and Edward Siwy; (second row) J. Willard Bossung, Albert Dickau, Louis Siwy, Michael Milek, George Henry, Chief Michael Muccio, Edward Dickau, William Connery, Harold Carozza, Gordon Wolldridge, and Francis Muccio; (third row) Charles Schmidt, Herbert Olcott, William Zesut, John Thurz, Arthur Zerver, Raymond Muccio, Clarence Dickerman, John Stec, Ed Behrendt, George Milek, Leonard P. Barker, Francis McCue, Frank Drusbacky, Harry Schmidt, Joseph Muccio, and Alex Pudlo. Pictured at the left is Chief Muccio. In 1937, he was killed in an automobile accident in Colchester at age 48. Chief Muccio's funeral, attracting over 2,000 mourners, was the largest funeral ever held in Glastonbury. (Both, courtesy of the collection of the Historical Society of Glastonbury.)

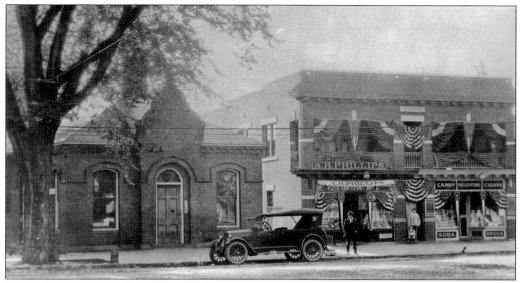

The building on the left is the Glastonbury Police Station in 1920. It was built in 1881 as the town records building and was demolished in 1970. Up until the 1920s, Glastonbury was protected by a system of constables. In 1927, one of the six constables, Michael Muccio, was appointed police chief and assigned a cruiser.

The South Glastonbury Post Office is pictured on this early-20th-century postcard. At other times, the building housed a general store, tavern, and dry-cleaning business. South Glastonbury boasts the oldest church building in town, now the South Glastonbury Public Library; the Cotton Hollow ruins; and the landing of the Glastonbury-Rocky Hill Ferry.

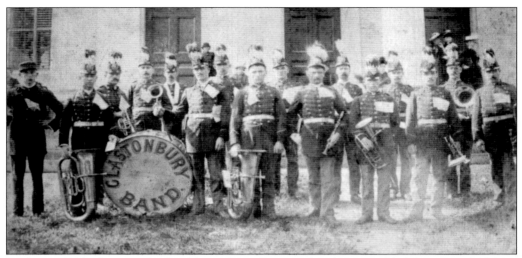

In this c. 1880 photograph, the Glastonbury German Band is assembled for a parade. Many German immigrant families moved to Glastonbury and became actively involved in their new community. Some arrived after the Franco-Prussian War. About three decades earlier, German families, led by the Korniebels, found jobs in the town's factories. As soon as it was feasible, they helped build the Lutheran Church of St. Mark.

Goodwill Grange was organized at Glastonbury's Masonic Hall on October 14, 1891, with 47 charter members. When it celebrated its 50th anniversary in 1941, it honored Harold B. Waldo, its only surviving charter member. Founded in 1867, the Grange is an American fraternal agricultural organization and an advocate of political, economic, and social issues important to farmers.

Firewood is cut and ready to be brought inside, as six men at the Glastonbury Young Men's Club pose for this photograph in 1904. The spirit of this club lives on in Glastonbury through today's Teen Center, the Teen Trip Series, and the Teen Action Group.

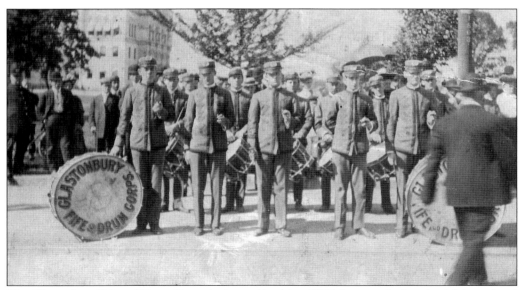

The Glastonbury Fife and Drum Corps is pictured in this c. 1910 photograph. In colonial times, local militia groups often had fifers and drummers provide their marching music. Today's fife and drum corps march in parades and participate in Revolutionary War and Civil War reenactments.

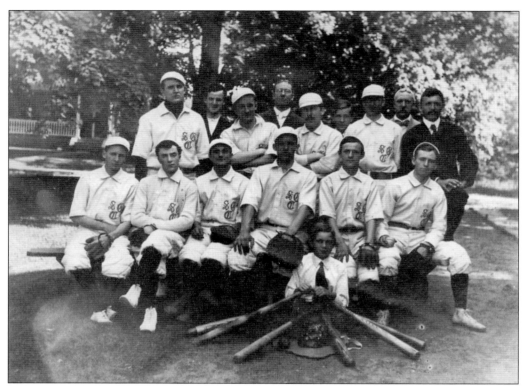

Members of the South Glastonbury Baseball Club proudly pose in their uniforms, with their bats and gloves, for a team photograph on High Street around 1902. Baseball has always been a popular sport in town with industrial leagues and, of course, school competitions.

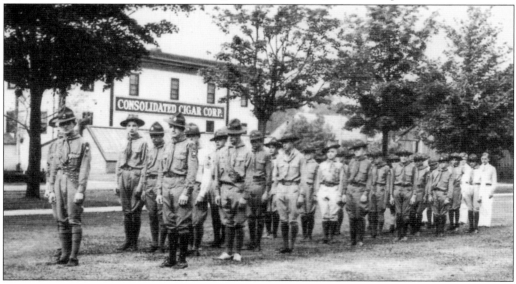

Boy Scout Troop No. 34 is marching on Hubbard Green. This troop was Glastonbury's oldest unit, first chartered in 1916, only six years after the Boy Scouts of America was founded. The Consolidated Cigar Corporation Building in the background still stands today, albeit unoccupied.

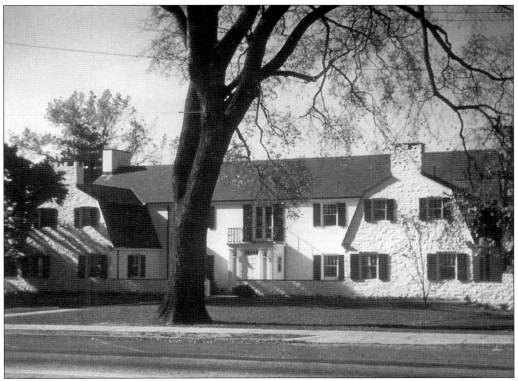

This early morning photograph was taken to commemorate the 1960 dedication of rooms in Welles Turner Library. Upon her death, Harriet Welles Turner Burnham (1856–1931) left $350,000, her home, and land in a trust, directing that they be used to build and maintain a public library. After her husband, Sturgis Turner, died, their house was moved to 2247 Main Street. The library was completed in 1952, and additions were constructed in 1965 and 1999.

The interior view of the Welles Turner Library is seen in this 1960 photograph. The original library was designed by architect Roy D. Bassette to look more like a house than most libraries. This room is furnished with Windsor chairs, drop-leaf tables, and a grandfather clock to give the library a homey feel.

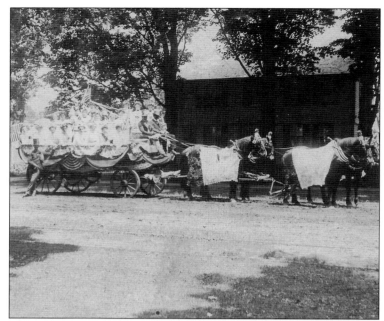

Riding on the wagon in this July 4, 1902, parade were Sarah Goodrich, Alice Simpson, Bertha Olcott, Evie Miller, Bertha Warner, Fannie Conklin, Marion Payne, Lucy Forbes, Maud Samson, Lillian Warner, Jennie Hollister, Lena Chapman, Ellen Welles, Martha Townroe, and Nellie Griswold. The coachmen were Charlie Goodrich and Henry Hollister. (Courtesy of Susan G. Motycka.)

On October 1, 1913, Glastonbury celebrated its 260th anniversary with "Glastonbury Day." The morning's major attraction was a parade that started near the Bates Hotel on High Street in South Glastonbury and ended at the green. Float sponsors included the Good Will Grange and the Camp Fire Girls. A program of religious and patriotic songs was held on the green after the parade, followed by athletic events, such as the wheelbarrow race, the fat men's race, and more traditional contests.

During the winter of 1939, a mysterious creature was spotted in Glastonbury. People who saw it said it looked like a composite of several animals: a lion, panther, dog, and bear. A *Washington Post* article stated, "Farm dogs have been found with their heads bitten off, cloven hoof prints have been discovered in the snow and also cat foot tracks measuring four inches across." Theories about its origin abounded. Some thought it was a wild boar or a species of big cat that came down from Canada. A good possibility is a fisher cat, which is a member of the weasel family. It looks like a small bear with a cat's head. Local hunters organized a safari in 1939 but came back empty-handed. An editor at the *Hartford Courant* coined a name for the creature, "Glawackus." It was derived from the first letters of Glastonbury, "wack" for "wacky," and the Latin ending "us." The animal has not been seen for decades.

Many town citizens gathered in their hats and costumes as they were captured in this 1924 Glastonbury Historical Pageant photograph. In honor of the early Glastonbury industry of hat making, the group "The Hatted Squires" presented a dance number. Participants included Marion Sherman, Louis Manning, Ruth Neuschler, Lawrence Smith, Polly Neuschler, Charles Boyce, Hazel Potter, Arthur Jacobs, Bernice Potter, Merton Hodge, Florence Dunn, John Dunn, Cornelia Pollard, and Joseph Ledgard.

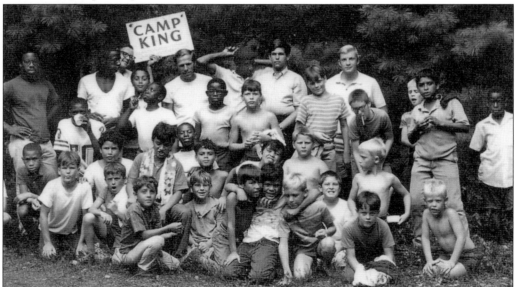

Camp King and Camp Together were two nonprofit multiracial camps founded in Glastonbury in the 1960s. They provided summer recreation and tutoring programs for kids from Hartford and nearby communities. Camp King, designed for 10 to 12 year olds, was first held on private property on Neipsic Road.

# Nine

# FLOODS AND HURRICANES

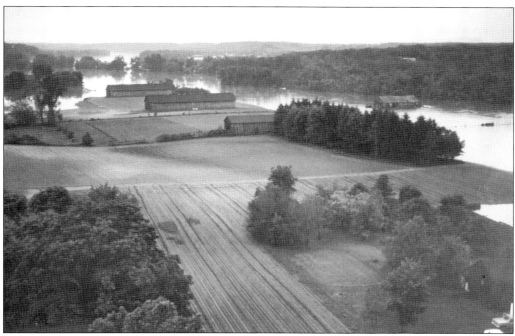

Flooding along the Glastonbury portion of the Connecticut River has always been a common occurrence. Known as the Great Meadows, the river's floodplain and wetlands south of Hartford comprise over 4,000 acres in the towns of Glastonbury, Rocky Hill, and Wethersfield. This includes farmland and the largest freshwater marsh in Connecticut. In this photograph, Glastonbury is on the left and Rocky Hill is on the right.

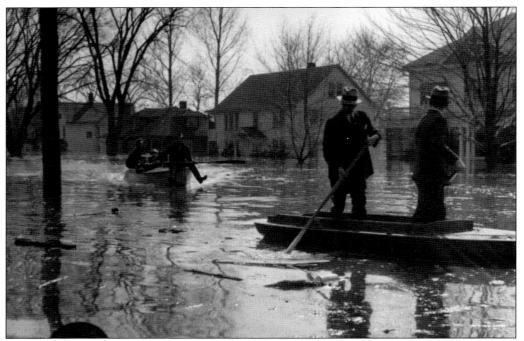

Small boats were the order of the day on Main Street, south of Hubbard Street, during the 1936 flood. In March of that year, the Connecticut River rose to the highest level ever recorded: 30 feet. Much of Main Street was flooded so badly that residents could only leave the center of town by going to the east. By the time the river crested at 37.5 feet, almost 250 families had been evacuated.

During the 1936 flood, Main Street looked like a waterway in front of the William Miller House. That same year, Dr. Lee J. Whittles moved in at 2205 Main Street. A medical doctor in Glastonbury for 40 years, Doctor Whittles was in charge of medical care during the 1936 flood and the 1938 hurricane. He was also a founder of the Historical Society of Glastonbury.

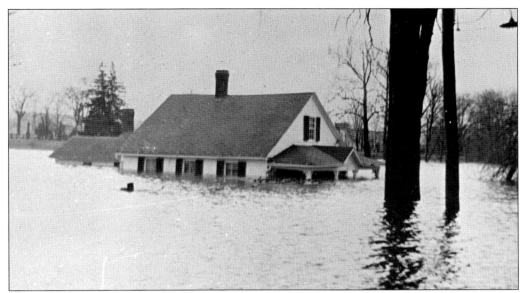

Floodwaters surround the historic "Conference House" near Hubbard Brook in 1936. Built about 1830, the First Church used it for meetings and concerts beginning in 1837. In 1894, it was bought by Deborah Goodrich Keene and moved across Main Street. In 1911, she leased it for use by Glastonbury's first telephone exchange. The first telephone had come to Glastonbury 28 years previously.

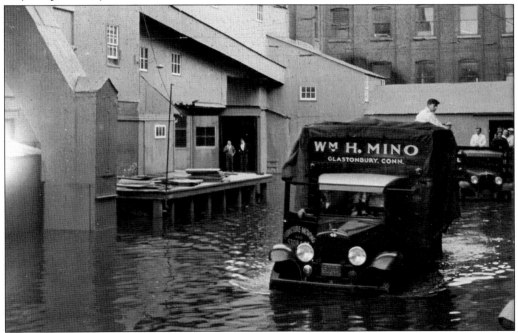

The 1936 flood affected the J.B. Williams Co. as well as Mino Trucking. When it closed down its Glastonbury operations in 1960, the Williams company was the oldest industrial firm in the town. Often the largest taxpayer in Glastonbury, the company employed a maximum of about 230 people. When its operations closed in town, its Glastonbury facilities employed only 70 employees.

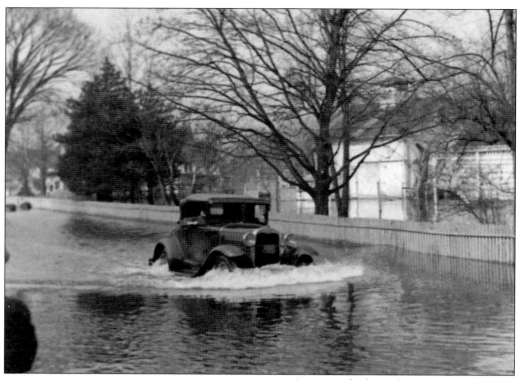

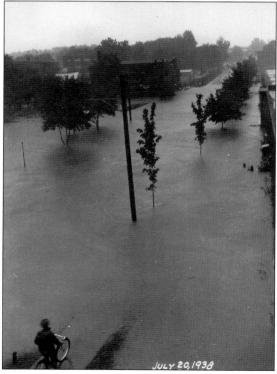

JULY 20, 1938

A car treads through water at Naubuc Avenue near Main Street after the 1936 flood. Although floods this serious fortunately have been an infrequent occurrence in Glastonbury's history, the town's proximity to the Connecticut River has often resulted in flooded meadows. One humorous episode occurred in 1933 when a small piece of driftwood became tangled on bushes near the ferry. Aboard it were two skunks, a rabbit, a woodchuck, and five field mice of three different species.

On August 13, 1955, Hurricane Connie dropped four to six inches of rain on Connecticut. Five days later, Hurricane Diane dropped another 14 inches within a 30-hour period. The floods hit on the 19th, but the season had not ended its devastation until two months later, when another major flood hit Connecticut on October 16.

The Buckingham Congregational Church on the corner of Hebron Avenue and Weir Street is shown here in 1904, several decades before the Great Hurricane of 1938. Formerly named the parish of Eastbury and then the East Glastonbury Congregational Society, it became Buckingham in 1873. It was the name of Connecticut's Civil War governor William Buckingham (1804–1875).

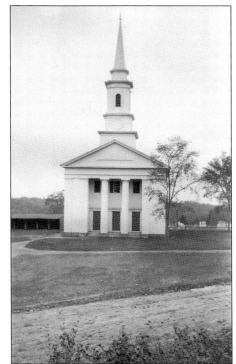

Here is the Buckingham Congregational Church as it appeared after the Great Hurricane of 1938. Albert Barrows built both this church and First Church on Main Street in 1866, and both were destroyed by the 1938 hurricane. The Buckingham Church was rebuilt to a smaller scale reflecting its declining membership.

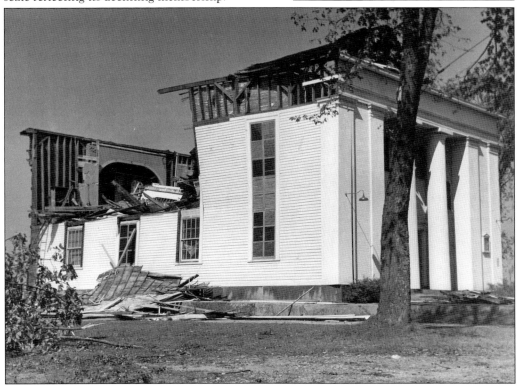

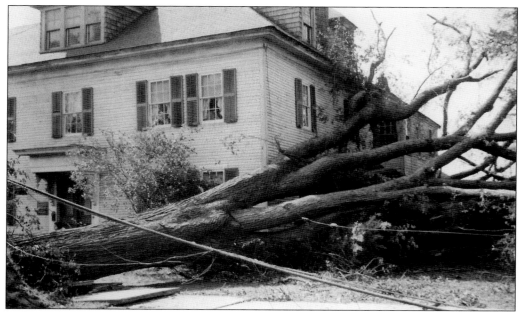

A downed tree struck Welles-Chapman Tavern at 2400 Main Street during the Great Hurricane of 1938. Built in 1776 by Joseph Welles, it was acquired by Azel Chapman in 1808 and was a stopping place for stages on the Hartford-to-New London route. In 1974, to accommodate the expansion of a bank, it was moved from the west to the east side of Main Street. The Historical Society of Glastonbury now owns this building.

Men dig up the stump of a fallen giant after the 1938 hurricane toppled it. The Great Hurricane of 1938 was traveling at 60 miles per hour when it reached Connecticut on September 21, 1938. A low-pressure reading of 27.94 inches was recorded in Hartford. The Connecticut River reached about 20 feet above flood stage. The hurricane resulted in 682 deaths, of which 564 were in southern New England.

## *Ten*
# WARS AND VETERANS

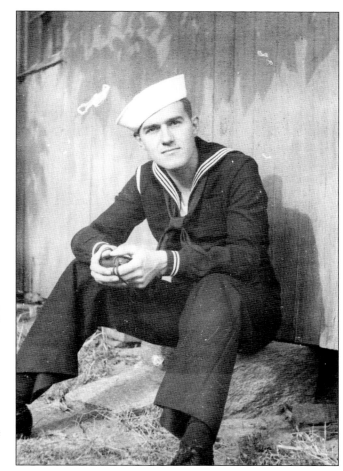

Natale "Nat" Sestero poses for a picture soon after he enlisted in 1943. Born in New York City, he lived in Glastonbury since he was an infant. In World War II, he served aboard the destroyer *John D. Henley* and participated in many actions, including the invasions of Iwo Jima and Okinawa. Back home after the war, he began a career with the *Hartford Times*, rising to become managing editor in 1968. He passed away in 2010 at age 96.

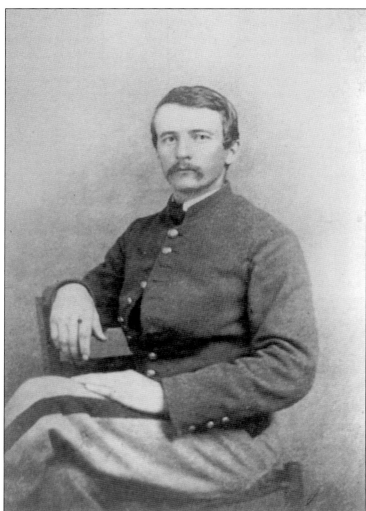

Civil War sergeant Patrick Henry Goodrich served at Chancellorsville, Gettysburg, and the 1864 campaigns in Tennessee, Georgia, and North Carolina. Growing up in South Glastonbury near the Portland line, he enlisted in Connecticut's Buckingham Legion, 20th Regiment, in 1862 at age 22. Discharged in 1865, he married Helen Wells of Portland in 1869.

In 1875, Patrick Henry Goodrich and his brother Evarts Edwards Goodrich established a general store in the building now housing Katz Hardware on the corner of Main Street and Naubuc Avenue. This is an 1880 receipt from his flour, grain, and grass seed enterprise. In 1884, Patrick founded the Riverside Manufacturing Company near the steamship dock in Naubuc. Also, he was involved in coal, tobacco, and banking businesses.

Pictured here is Martin Roser. Like his brothers, Roser served in the American forces during World War I. After being told by several recruiting offices that his nearsightedness disqualified him from serving, he memorized the eye chart and was accepted. Within a month of enlisting, he was assigned to the 312th Machine Gun Battalion in Europe.

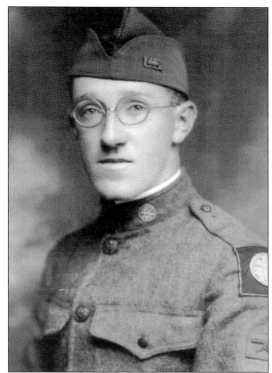

Pictured is the Glastonbury branch of the American Red Cross in front of the Civil War monument on the Old Town Green in 1919. The occasion was the welcome home celebration for returning World War I servicemen. At the time this photograph was taken, the massive influenza pandemic that claimed about half a million lives in the United States was just ending. The American Red Cross was instrumental in combating it.

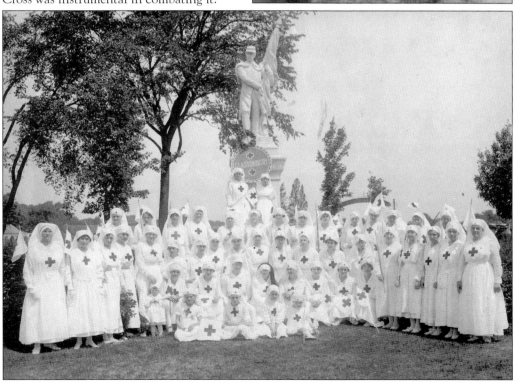

A house is trimmed for the Glastonbury Welcome Home Parade of 1919. On March 30, 1919, the First Congregational Church hosted a welcome home meeting for about 50 soldiers and sailors. It began with an address by Rev. Frederick Raymond and was followed by a roll call of Glastonbury's soldiers in France by Lt. Albert Simons of Hartford. Music included the singing of camp songs, a violin solo by Louise Olcott, and a soprano solo by Anna Talcott.

In the above picture, Helen Hurlburt, Phil Dean, Phil Carter, and Dom Carter take part in a Memorial Day celebration on the Glastonbury Green. Elizabeth Affleck and Phoebe Holmes were among the participants of the gathering. This has always been an important holiday for the people of Glastonbury.

Honor Prince Kingsbury, the daughter of Glastonbury medical doctor William Kingsbury and Mary Raymond, served in the Red Cross. Born in 1907, she had an older sister, Elizabeth. After the war, Honor taught in the Glastonbury school system.

Starting in early 1942, the US Office of Price Administration froze prices on many common goods and distributed war ration books and tokens to American families. These limited how much gasoline, tires, fuel oil, sugar, coffee, cheese, meat, shoes, nylon, and other items a person could buy. The book below was issued to George Trepp of Overlook Road, Glastonbury. Trepp retired as senior vice president of Connecticut Bank and Trust in 1972 after 46 years of service.

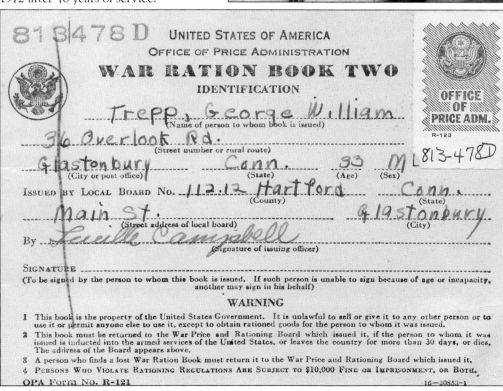

813478 D **UNITED STATES OF AMERICA**
OFFICE OF PRICE ADMINISTRATION

# WAR RATION BOOK TWO
### IDENTIFICATION

Trepp, George William
(Name of person to whom book is issued)

36 Overlook Rd.
(Street number or rural route)

Glastonbury (City or post office)　　Conn. (State)　　33 (Age)　　ML (Sex)　　813-478 D

ISSUED BY LOCAL BOARD NO. 112.12　Hartford (County)　　Conn. (State)

Main St. (Street address of local board)　　Glastonbury (City)

By ___Lucille Campbell___
(Signature of issuing officer)

SIGNATURE _____
(To be signed by the person to whom this book is issued. If such person is unable to sign because of age or incapacity, another may sign in his behalf)

### WARNING

1　This book is the property of the United States Government. It is unlawful to sell or give it to any other person or to use it or permit anyone else to use it, except to obtain rationed goods for the person to whom it was issued.
2　This book must be returned to the War Price and Rationing Board which issued it, if the person to whom it was issued is inducted into the armed services of the United States, or leaves the country for more than 30 days, or dies. The address of the Board appears above.
3　A person who finds a lost War Ration Book must return it to the War Price and Rationing Board which issued it.
4　PERSONS WHO VIOLATE RATIONING REGULATIONS ARE SUBJECT TO $10,000 FINE OR IMPRISONMENT, OR BOTH.

OPA Form No. R-121　　　　　　　　　　　　　　　　　　16—30853-1

The welcome home celebration in 1946 included this smorgasbord dinner in the Grange Hall on Naubuc Avenue. Speeches were the only things omitted from the dinner. Almost 500 of Glastonbury's 1,000 World War II veterans took part in the festivities.

Following the dinner, a welcome home dance was held in the auditoriums of the high school and the Williams Memorial. Each veteran was allowed to invite one guest. The following morning, which was a Sunday, all Glastonbury churches held services welcoming them home too. That afternoon, the US Coast Guard Academy Band presented a concert on the Old Town Green.

This World War II welcome home party was held on June 29 and 30, 1946. Glastonbury's sons and daughters have a proud tradition of serving their country in times of need. During the Vietnam War, Air Force sergeant John Lee Levitow's act of "conspicuous gallantry" aboard a military plane saved the lives of his fellow servicemen. He received the Congressional Medal of Honor in 1970.

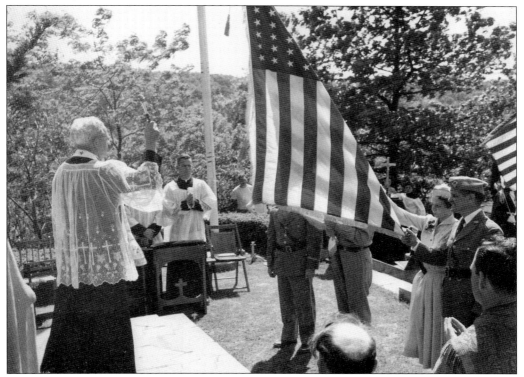

Dedication of the war memorial in St. Augustine's Cemetery on Hopewell Road occurred on May 27, 1945. Speaking at the dedication, Connecticut congressman Herman P. Kopplemann said, "We do not seek to enslave people, economically or spiritually. Our policy has always been one of give and take, do unto others as you would have them do unto you. The selfishness which breeds wars has never been a part of us."

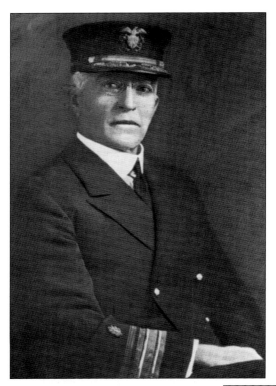

US Navy rear admiral George Holcomb Barber grew up in Glastonbury and attended its public schools. He was on the staff of the Medical Department of New York's Columbia College in 1888, appointed US Navy assistant surgeon in 1889, and commissioned rear admiral in 1917. He was a lieutenant and a surgeon during the Spanish-American War. He died at age 61 in 1926 and was buried in Glastonbury's St. James Cemetery.

Nurse Florence Megson stands dressed in her World War II Red Cross uniform in the 1940s. A lifelong Glastonbury resident, she was the daughter of Edward and Ellen Ann Heywood Megson. During the war, she served on the hospital staff at Hawaii and Guam. In civilian life, she was a life insurance underwriter. She was an active supporter of St. Luke's Episcopal Church of South Glastonbury, the Red Cross Bloodmobile Program, and Newington Children's Hospital. Megson died in 1987.

In this picture, Anthony "Pie" Manfredi is standing under the World War II aircraft-spotting tower on Glastonbury's Tower Hill. Once the United States entered the war and submarines posed a threat to ships off the Eastern Coast, attacks from the air were anticipated. Aircraft spotting towers were established throughout the country. Some used existing church steeples, while others, like the one in Glastonbury, consisted of small rooms or platforms perched on the top of four legs.

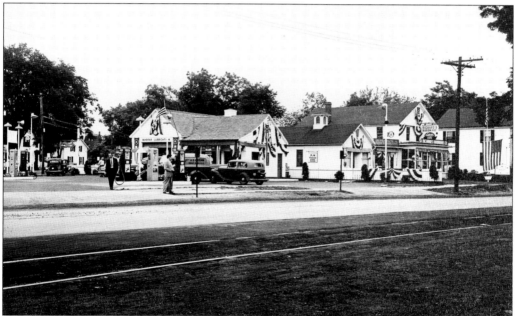

Glastonbury's streets are festooned with patriotic red, white, and blue banners as the community welcomes home its heroes after World War II. The sign on the right of photograph states, "Welcome Home Buddies Job Well Done." During World War II, almost a 1,000 men and 20 women from Glastonbury served their country in the military. Twenty-seven never returned.

# BIBLIOGRAPHY

Bissland, Jim. *Long River Winding: Life, Love, and Death along the Connecticut*. Lee, MA: Berkshire House Publishers, 2003.

Chapin, Alonzo B. *Glastenbury for Two Hundred Years*. Hartford, CT: Press of Case, Tiffany and Company, 1853.

De Forest, John William, *History of the Indians of Connecticut From the Earliest Known Period to 1850*, Hartford, CT: William J. Hamersley, 1851.

*Glastonbury: Its Beauty and Bounty*. McNulty, J. Bard. The Historical Society of Glastonbury, 1993. Videocassette.

*Hartford Courant*.

Hedden, Daniel T. *The Glastonbury Express*. Glastonbury, CT: The Historical Society of Glastonbury, 1990.

McNulty, Marjorie Grant. *Glastonbury: From Settlement to Suburb*. Glastonbury, CT: The Historical Society of Glastonbury, 1983.

———. *A Moment in History*. Glastonbury, CT: The Historical Society of Glastonbury, 1983.

*New York Times*.

Petrash, Antonia. *More than Petticoats: Remarkable Connecticut Women*. Guilford, CT: The Globe Pequot Press.

Von Wodtke, Henry. *Glastonbury's Main Street, A Self-Guided Tour*. Glastonbury, CT: The Historical Society of Glastonbury, 2004.

*Washington Post*.

Welles, Gideon. *Diary of Gideon Welles*. Boston, MA: Houghton Mifflin Company, 1911.

# INDEX

# DISCOVER THOUSANDS OF LOCAL HISTORY BOOKS
## FEATURING MILLIONS OF VINTAGE IMAGES

Arcadia Publishing, the leading local history publisher in the United States, is committed to making history accessible and meaningful through publishing books that celebrate and preserve the heritage of America's people and places.

Find more books like this at
**www.arcadiapublishing.com**

Search for your hometown history, your old stomping grounds, and even your favorite sports team.

Consistent with our mission to preserve history on a local level, this book was printed in South Carolina on American-made paper and manufactured entirely in the United States. Products carrying the accredited Forest Stewardship Council (FSC) label are printed on 100 percent FSC-certified paper.

MADE IN THE USA